INTRODUCTION

Everything that is great happens in ...

Drawing animals is just as fascinating as drawing the human figure: both activities involve portraying living beings, each with their own character and personality, their own particular temperament and physical characteristics. The key to producing a good drawing of an animal is knowledge and understanding – not only of its physical structure but also of its habitual behaviours and instinctive reactions, allowing you to show not just the physical characteristics of a species, but also the idiosyncratic character of the individual animal.

Artists who dedicate themselves to the study of nature, and in particular to the portrayal of animals from life, do not need to travel to distant locations in order to track down and observe animals in the wild – they can easily turn to those in their local environment, such as household pets – cats, dogs and birds – and the animals reared on farms or those housed in zoos and in wildlife parks. Another starting point for your first steps in practising the drawing of animals could also be the natural-history department of a museum (see pages 52–64).

When drawing a domestic animal from life, it is best to do so from a distance. There are several reasons for this: the whole of the animal will be visible; perspective distortions will be avoided; the animal's overall form can be appreciated, whether in movement or at rest, and the subject will not be disturbed by your presence, which may happen if you meet the animal's gaze and stare directly into its eyes.

Drawing plays an important role in the scientific study of nature, and some drawing techniques are ideally suited to naturalistic or anatomical study, for describing the subject and analysing its form and structure. There is also the 'artistic' approach, which focuses on the expressive aspect of an animal's behaviour and movements, and on its bodily appearance.

The history of the artistic representation of animals goes back a long way. Cave paintings from prehistoric times are the oldest surviving drawings and they often depict animals. Since then, particularly in painting but more frequently in sculpture and decoration, the art of every civilisation has seen animals as subjects of great symbolic power and fascination. There is even a great tradition in the art of animal portraiture, which is still very much alive, and represents a significant part of the activity of professional 'animal artists'. Animal owners, especially the owners of thoroughbred horses or pedigree dogs and cats, are very fond of having portraits of their loved ones on show.

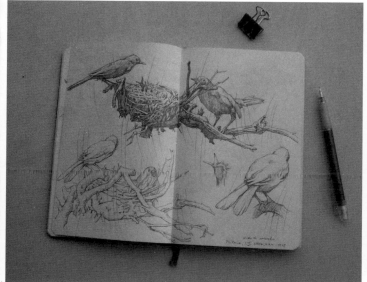 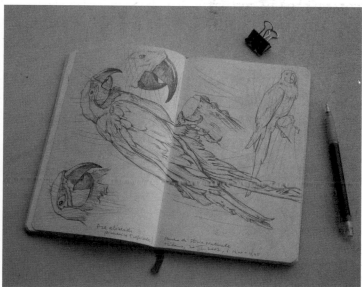

Pages from sketchbooks dedicated to the study of natural history.

SOME PRACTICAL CONSIDERATIONS

It is much easier to draw a fragment than the whole. Perhaps a part is already an entirety and what seems incomplete is already finished.

TOOLS, MATERIALS AND TECHNIQUES

As with any other subject matter, the simplest and most obvious tools can be used for drawing animals, especially when working out in the open, directly from life: pencils, charcoal, pen and ink, felt-tipped pens, ink-wash, etc. Each of these materials will produce its own effects when its associated techniques combine with the characteristics of the working surface, be it smooth or textured paper, card or tinted paper, for example. For the pictures in this book, I have restricted myself to that classic drawing combination, pencil on paper, in order to help me concentrate on observing each organism's form and structure. I used a mechanical pencil with a 0.5mm HB lead and a 15 × 21cm (6 × 8in) sketchbook. You may also wish to explore the chromatic qualities of animals' coats using techniques that combine drawing with coloured media such as coloured pencil, watercolour or gouache.

WHERE TO FIND YOUR SUBJECTS

While wild animals should be studied in their natural habitats or, failing that, in wildlife parks or zoos, domestic animals can, of course, be observed from life in a variety of everyday locations and circumstances. Cats and dogs, for example, can be found just about everywhere, whether you are in the countryside or in a town. It may be a little more difficult to find horses, cattle, donkeys and other 'farmyard' animals but riding stables or livestock farms are usually easy to find, and a visit to them will help any artist. There are also regular seasonal events, such as county fairs, pet shows and sporting events, which feature various species and breeds of dogs, cats, horses or birds. A visit to a natural-history museum will provide an opportunity for a more scientific type of study, which will prove useful for acquiring a detailed understanding of anatomical structure, the details of external forms and of the comparative differences between kindred species. If this is your chosen location, pay attention to the accuracy of anatomical proportions, as the animals on display in museums are usually a product of the taxidermist's art, and artificial aids or dodges may have crept into the preparation of bone structure and musculature that may not be obvious beneath the feathers, fur or skin.

HOW TO STUDY ANIMALS

The greatest challenge to an artist attempting to draw living animals is the unpredictability and speed of their movements. Human subjects can voluntarily hold a pose for the amount of time it takes to depict them, but animals, whether domestic, domesticated or wild, cannot be made to hold completely still. It is, however, possible to makes studies of them while they are asleep, while they are eating or engaged in gentle play. It is always a good idea to spend time just observing an animal's movements from a distance and trying to learn the cyclical pattern of behaviours by guessing the direction and nature of the next movement. You will then find that you can draw during the repeated phases of relative stillness. Luckily for the artist, much of the behaviour of domestic animals is repetitive and, with a little patience, you can turn this to your advantage by discovering how they always return to a few typical positions.

There is no doubt that drawing from life is the best way to portray animals as it forces the artist to observe directly and carefully and to give physical form to his aesthetic feelings. Artists can make drawings from life that are highly detailed and faceted or, at the opposite extreme they can make quick sketches as a means of simple visual note taking, which can later serve as a reminder and be a starting point for a more complex and highly finished work. It is a good idea to keep a pencil and a pocket sketchpad at hand because the best opportunities for making rapid studies tend to come when we least expect them, and such opportunities may not be repeated.

If the subject's constant motion prevents you from making even the most rapid and cursory sketch from life, or if you are looking for other sources of recorded images for a work to be executed later, photographs, film or television documentaries could prove useful. Today, technology allows us to 'freeze' animal movements, which offers a faithful record of animal behaviours and habitats. If you decide to take photographs yourself for this purpose, pay careful attention to possible distortions created by the camera lens and consider how a photographic image can alter an object's proportions, especially in three-quarter view and in close-up.

HOW AND WHAT TO OBSERVE

Drawing is a way of seeing. Whatever subject matter you intend to depict by means of lines on paper (in this instance, domestic animals) the most effective approach is to move from observation to understanding and then to interpretation. In the text that follows, you will find practical ideas to help when drawing pets, many of which are explained in more detail later in this book.

The first lines to be drawn should delineate the animal's overall form. Various techniques can be used to do this: for example, reduce each form to a simple geometrical shape such as a square or a circle; outline the large bodily masses using a few lines, or make a schematic diagram of the main skeletal shapes – the cranium, the spinal cord, the pelvis, etc.

There is no ready formula, of course, for bodily proportion and anatomical layout that can be applied like a template to each and every animal, but there is a general structural scheme for each species, and it is possible to outline the main construction principles shared by all quadruped vertebrates. However, remember the variations within each species (i.e. all the different breeds of horse or dog), as well as individual differences.

It is a good idea to acquire a sound theoretical knowledge and take a methodical approach. When drawing animals, you should concentrate on developing one or two specific skill sets

to help you interpret and combine the data derived from nature into a coherent whole. Examples of areas to consider and develop through your drawing could include the following: anatomy; the ability to analyse form, structure, movement and balance; knowledge of a species' characteristics – its behavioural habits and physical traits, such as the way its skeleton, musculature and body form have adapted to suit its environment; the characteristics of an individual example; diversity of size and form in relation to sex and age; typical postures and behaviours, and characteristic mannerisms.

The complexity of the issues involved when drawing animals, and the need to avoid giving these a superficial or unconsidered treatment, have caused some artists to specialise in observing only one particular species (e.g. dogs, horses, birds, etc.). This enables them to concentrate on understanding the general way in which these animals move, their habitual behaviours and reactions, in order to be better able to give a fully nuanced artistic treatment of each individual.

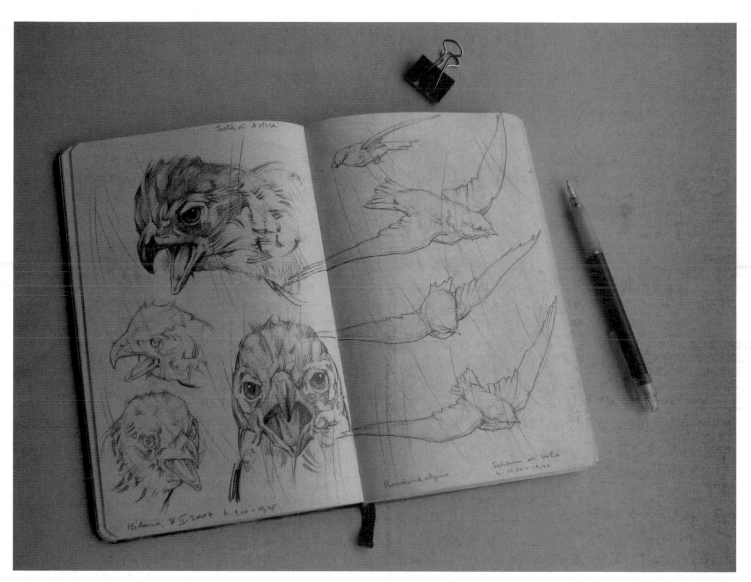

Birds are anatomically designed for flight, and their bones are hollow, making them lighter, while the wing-impelling muscles are strong and solidly built, with firm anchorage to the bones of the chest. Birds' bodies have an overall 'teardrop' aerodynamic shaping, which offers the least resistance to the air (see Chapter 7).

PERSPECTIVE

Perspective is used to represent spatial depth on a flat surface. These pages provide an overview of the basic geometrical principles of linear perspective, which creates an effect of spatial distance through progressive reduction in size of the objects portrayed. By following these basic principles, you will be able to correct and understand 'intuitive' perspective as it is perceived by the eye. In linear perspective, a sense of depth is re-created by tracing the apparent heights of objects on to one picture plane and gradually reducing these heights as they recede from the observer.

Perspective plays a particularly important role when drawing large animals, such as a large dog, a cow or a horse. When drawing such animals, the artist is often confronted with problems of foreshortening and of keeping the nearer and farther portions of the body in proportion. Single parts of the body, such as the animal's head, its legs or its tail will present themselves obliquely and in such a way that requires applying the rules of perspective – not necessarily in an unbending way, but adapting them to obtain an aesthetically acceptable likeness. What goes for individual animals, (and the shadows they project), also applies to groups of animals spread over a large area: it will be much easier to depict the size relations between one animal and another if careful attention is paid to the rules of linear perspective.

Two types of linear perspective may be of interest: central and two-point perspective.

Central linear perspective is not often needed in the depiction of organic forms, as it uses a single vanishing point on the horizon towards which all of the object's non-vertical lines converge. It is used when the object presents itself with one side parallel to the image plane.

Two-point linear perspective can be applied to many of the positions animals typically present in relation to the observer's viewpoint. The diagrams shown here are, I think, reasonably self-explanatory in their presentation of the most basic application of two-point perspective, but note the following:

- Two vanishing points (VP1 and VP2) are taken into consideration, located towards the ends of the horizon line.
- The horizon line (H) always corresponds to the eye-level of the observer, as determined by the observer's viewpoint, i.e. the position from which the object is being studied.

For the sake of clarity, the object shown in the diagram below is a simple geometrical shape. This type of perspective is applied when an object is viewed corner-on, with one of its upright corners being the only facet of the object that is parallel to the picture frame of the perspective view. All of the object's vertical lines remain vertical but they reduce in height as they get nearer to the horizon and appear to recede into the distance. This recession or foreshortening is determined by the way the object's horizontal lines converge towards one of the two vanishing points.

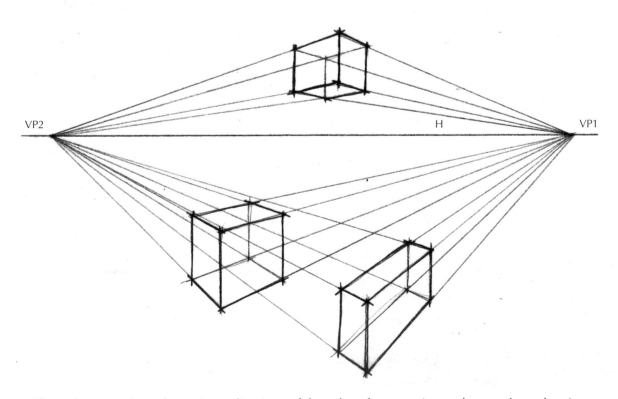

These diagrams show the main applications of the rules of perspective as they apply to drawing animals, especially large ones.

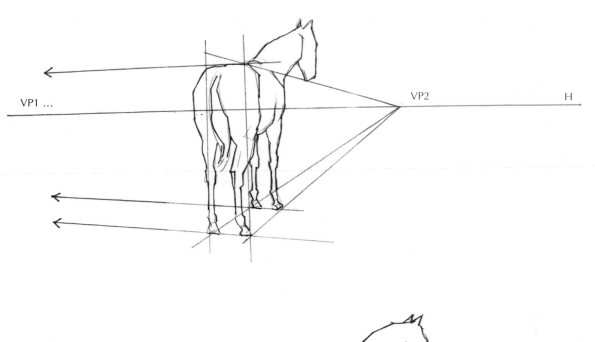

VP1 ... VP2 H

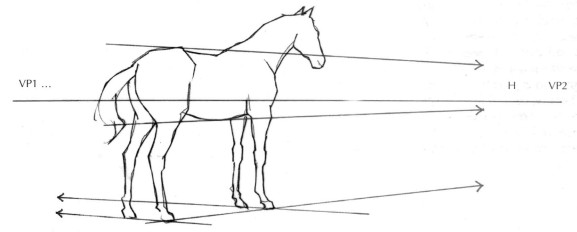

VP1 ... H VP2

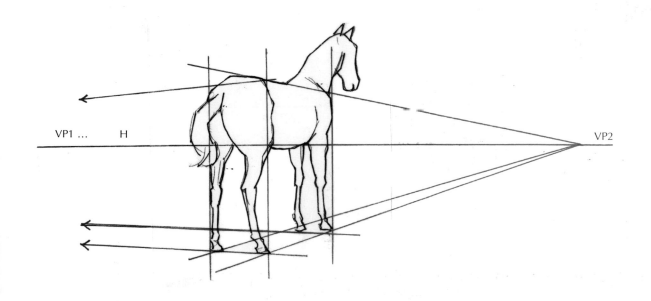

VP1 ... H VP2

ANATOMY

Art involves craft as well – and craft imposes its own harsh discipline.

Artistic representation requires the application of the intellect and the emotions modified by reasoning and analysis. Being more closely related to the analytical side, the study of the anatomy of animals, (comparative or zoological anatomy), is very useful for acquiring a sound knowledge of the basic structures of animals' bodies and, in particular, their bone structure. This knowledge will become especially important when attempting to portray constantly moving creatures from a distance or in complicated positions. The pets and other domesticated animals I have depicted in this book are all vertebrates (mammals and birds) but obviously the various species are all very different: cats and dogs are carnivorous mammals; horses and cows are both hoofed (ungulate) mammals although the horse belongs to the family of odd-toed hoofed mammals (perissodactylous ungulates) while the cow is an even-toed (artiodactylous) ungulate. Meanwhile, the chicken belongs to the galliforme order of birds.

It is of fundamental importance to have an anatomical understanding of musculature in order to produce accurate likenesses of the way animals move and to convey their pent-up energy. While the muscles determine an animal's exterior bodily form, their influence is often masked by the thickness of the skin or the shaggy mass of the animal's coat. An analysis of muscle anatomy when starting out with drawing animals is very useful. The ability to combine careful observation of animals from life with a sound understanding of the body's system of support – its bones – is also essential.

A BRIEF OVERVIEW OF ANIMAL ANATOMY

The skeletal structure of the animals described in this book consists of an axial section (the cranium and spinal column) and appendicular sections – the limbs. These two groups are linked together by the pelvic and thoracic girdles. The shape of the backbone reflects the fact that, unlike humans and birds, quadrupeds walk on four limbs and support themselves on the ground with the equivalent of their fingers or toes alone. (These animals are known as digitigrades.) Instead of consisting of a succession of curves, (the kyphosis and lordosis, or convex and concave curves of the human spine), which typify animals whose customary stance is an upright one, the backbones of quadrupeds are more regular in shape, resembling the arch of a bridge, (whose function is in some ways similar), as it extends from the cranium (skull) to the pelvis (hip), with a extension along the tail.

The cervical (neck) portion of a quadruped's spinal column always consists of seven vertebrae, with the overall length of the neck depending on the varying sizes of these individual components. The dorsal parts of the column: the thoracic (chest), lumbar (between chest and pelvis), sacral (pelvic)

and caudal (tail) sections have varying numbers of vertebrae in different animals. For example, the thoracic section of a horse's spine consists of eighteen vertebrae, while that of a cow has thirteen. The lumbar section comprises six vertebrae in a horse or cow, but seven in a dog. With birds, the cervical section is much longer and more mobile, having between twelve and twenty-five vertebrae, while the thoracic section is more compact, having only seven to nine. These variations correspond to the distinct body lengths of different species and to the relative lengths of trunk and limbs.

One important difference between quadrupeds and humans is that the former have no collarbones – the front limbs are connected to the trunk simply by strong, sturdy muscles. Another difference is the presence of long apophyses (anchor points for muscles) along the quadruped spine to provide the bearings for a complex system of ligaments such as the nuchal ligament which, attached to the nape at the back of the cranium, helps hold the head and neck erect without the need for muscular exertion.

The diagrams here and on the following pages provide a basic introduction to the bone structures and surface musculature of the animals depicted in this book. In order to follow up this introduction with a study of anatomy in much greater depth, it is a good idea to consult specialist publications and to examine animals' bodies.

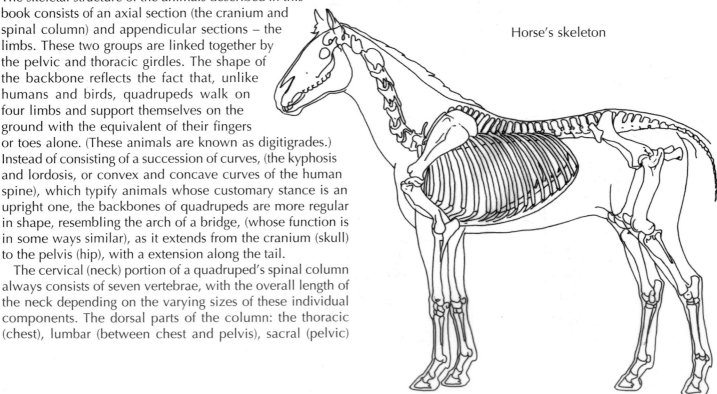

Horse's skeleton

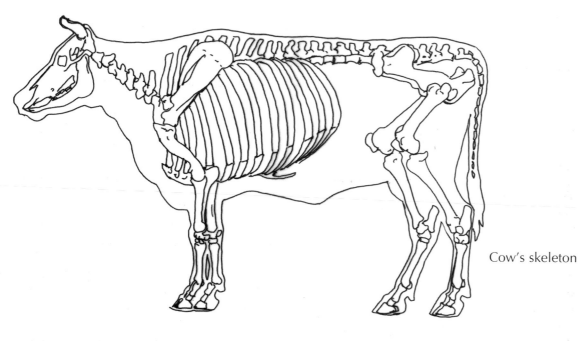

Cow's skeleton

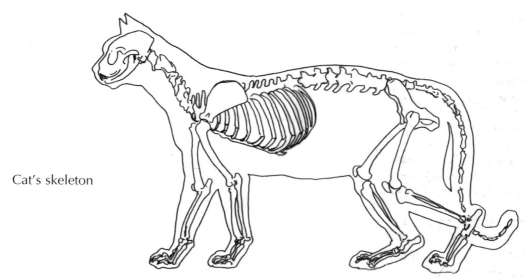

Cat's skeleton

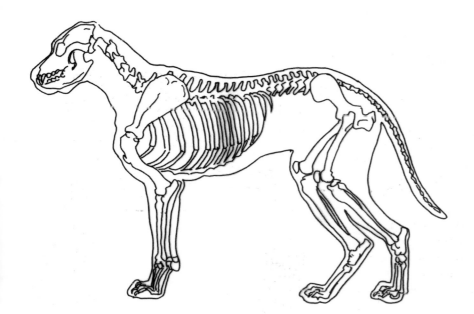

Dog's skeleton

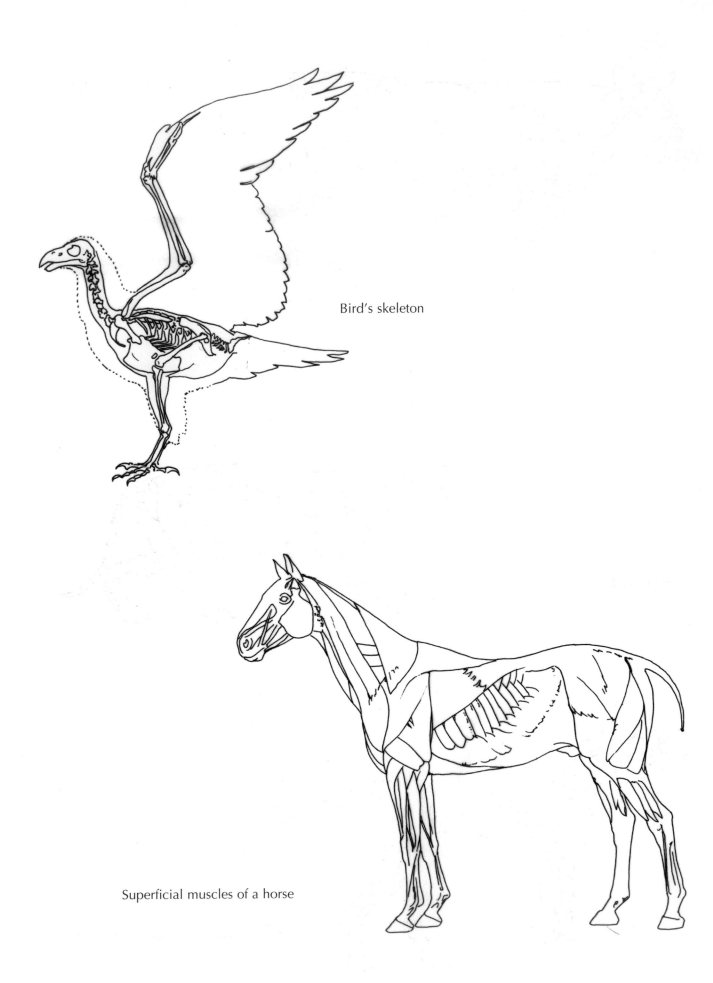

Bird's skeleton

Superficial muscles of a horse

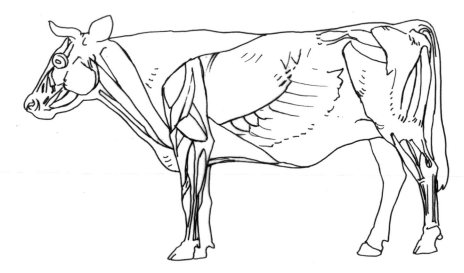

Superficial muscles of a cow

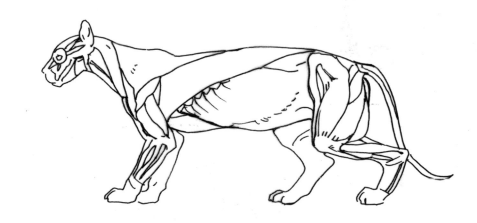

Superficial muscles of a cat

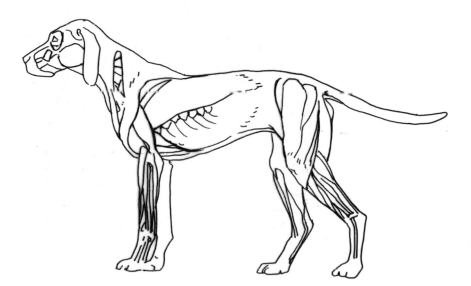

Superficial muscles of a dog

FORM, STRUCTURE AND MOVEMENT

Beauty speaks softly, discreetly and simply.

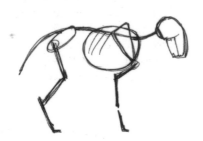

The main structural lines necessary (and sufficient) for rendering the gist of the shape, mass and bearing of an animal's body (quadruped vertebrate).

As with any organic form or object, it is advisable to begin drawing an animal by setting down a few lines on paper to delineate its overall shape. Begin with a rough but accurate sketch showing the elements of the essential skeletal structure (the backbone and the trunk, the cranium, pelvis and limbs) in their correct proportions,

as shown left. These lines lay the foundations for the drawing and they help characterise the typical structure of the species to which the animal belongs. For this reason, they can only be drawn after carefully analysing the subject, identifying its most important bodily masses and its most significant points of articulation. A further stage of the sketch could go on to summarise the body masses in terms of simple geometrical shapes combined with accurate observation of the body's axes, its slants and tilts, and the angles at which the different segments (the trunk, neck, limbs, etc.) meet. A later stage of working through the drawing will involve giving definition to the shapes of individual features – the eyes, nose, paws and hooves, etc. – as well as adding effects of light and shade to convey the characteristics of the animal's coat and bodily posture.

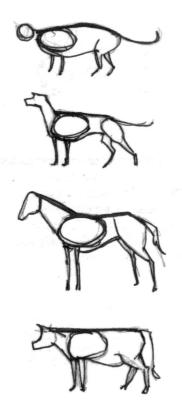

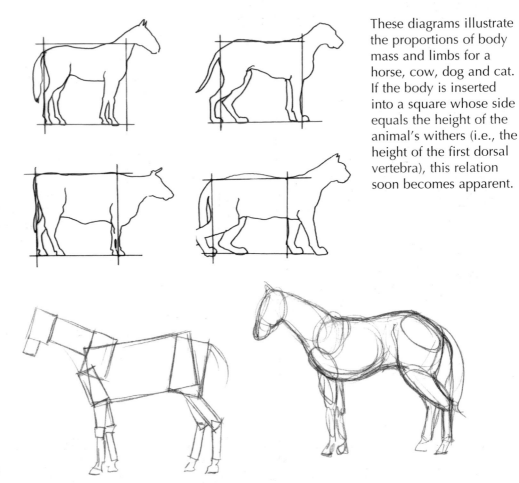

These diagrams illustrate the proportions of body mass and limbs for a horse, cow, dog and cat. If the body is inserted into a square whose side equals the height of the animal's withers (i.e., the height of the first dorsal vertebra), this relation soon becomes apparent.

From these lateral structural diagrams of a cat, dog, horse and cow, it is obvious how each animal's spinal column describes a different path and how the animal's head stands in relation to it.

The gist of an animal's basic structure can be indicated either by 'geometricising' its forms (above left) or simply by using free-flowing strokes of the pencil (above right). It is up to each artist to decide which of these approaches is preferable: the first method helps to 'construct' the form by spelling out the positions of each jointed segment in relation to the others and helping to establish proportions, while the second better conveys the dynamic and unified character of the organism.

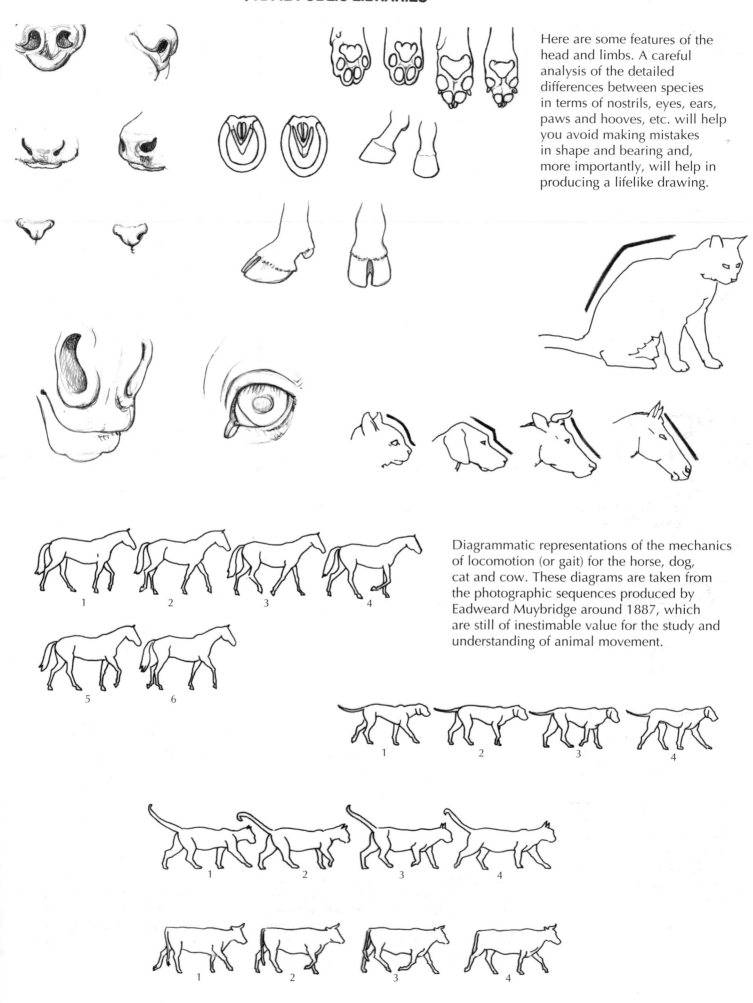

Here are some features of the head and limbs. A careful analysis of the detailed differences between species in terms of nostrils, eyes, ears, paws and hooves, etc. will help you avoid making mistakes in shape and bearing and, more importantly, will help in producing a lifelike drawing.

Diagrammatic representations of the mechanics of locomotion (or gait) for the horse, dog, cat and cow. These diagrams are taken from the photographic sequences produced by Eadweard Muybridge around 1887, which are still of inestimable value for the study and understanding of animal movement.

DRAWING TECHNIQUES

The best outcomes (not only in drawing) are achieved in the final moments.

A drawing can be approached in a variety of ways, with different aims and for different purposes. For example, there is the purely linear drawing of outline only or, at the opposite extreme, a purely tonal drawing in which form is created using tone, not line. Finally, of course, there are drawings that combine the two approaches to varying degrees. Some examples of aims and purposes include the drawing of an animal in order to carry out a 'scientific' investigation of its physical structure (an anatomical illustration), or to depict its typical habitat (a naturalistic illustration), or a drawing in which the aim is to express an aesthetic feeling (an artistic drawing). Of course, whatever the technique and procedure used, the extent to which it is elaborated and 'finished' can vary greatly – anywhere between the rapid sketch for gist, (or a 'gestural' sketch, which is even more bare and fluent), to a complex analytical study.

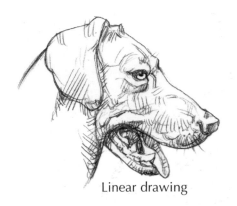

Linear drawing

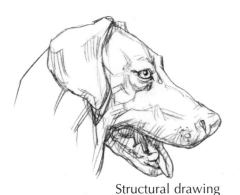

Structural drawing

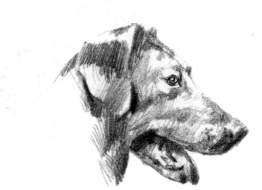

Tonal drawing

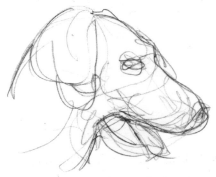

Analytical drawing

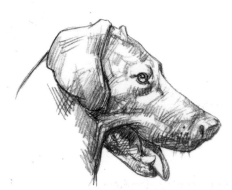

'Mixed' drawing (a combination of line and tone)

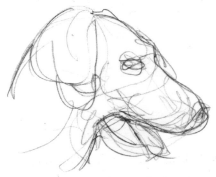

'Gestural' drawing

The choice of technique and style, and the depth of the study, is always left up to the artist's preferences or to professional demands. That said, it might be of use to suggest an elementary, traditional approach, which represents just one of many possibilities, but which has proven useful because of its great simplicity and intuitive ease (see the three-stage process set out below).

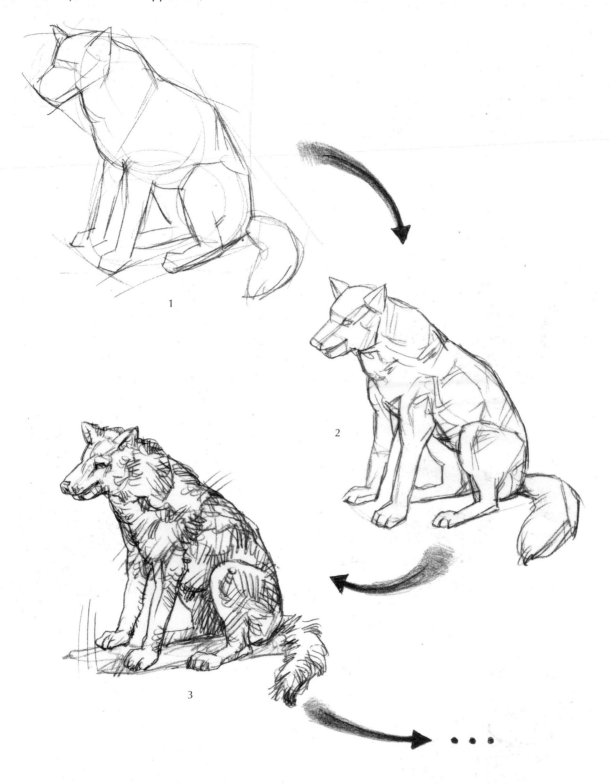

Step 1 Start with a schematic indication of the whole, using lightly drawn construction lines.

Step 2 Block in the interior forms of the structure.

Step 3 Work through the bodily forms and the details of the features by defining tonal areas, picking out structures, light and shade, etc.

SKETCHBOOK: DOGS

The dog is one of the most expressive, affectionate and lively of animals, much loved by nearly everyone. The origins of the domestic dog are lost in pre-history but its antique roots have produced a great variety of breeds (including hunting dogs, working dogs, guard dogs, racers and 'best friends') with wide variations in size and bearing between them. Dogs can be found in most environments and can be portrayed quite easily in their habitual positions of rest or when being fed. Dogs can also be trained to perform specific actions. It is not so easy, however, to depict them while they are playing or running or when they adopt unusual stances. In these cases, it is necessary to draw from memory, having carefully observed the actions when they occurred, or to make some very rapid sketches and then complete them, perhaps by making use of photographs. (If photographs are used, they should be taken from a suitable distance and angle to avoid distortions of perspective and proportion.)

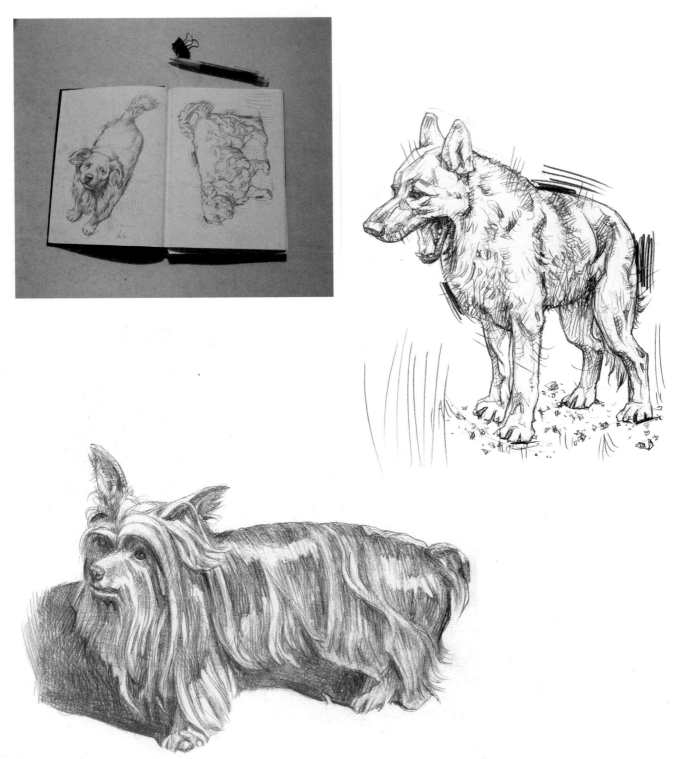

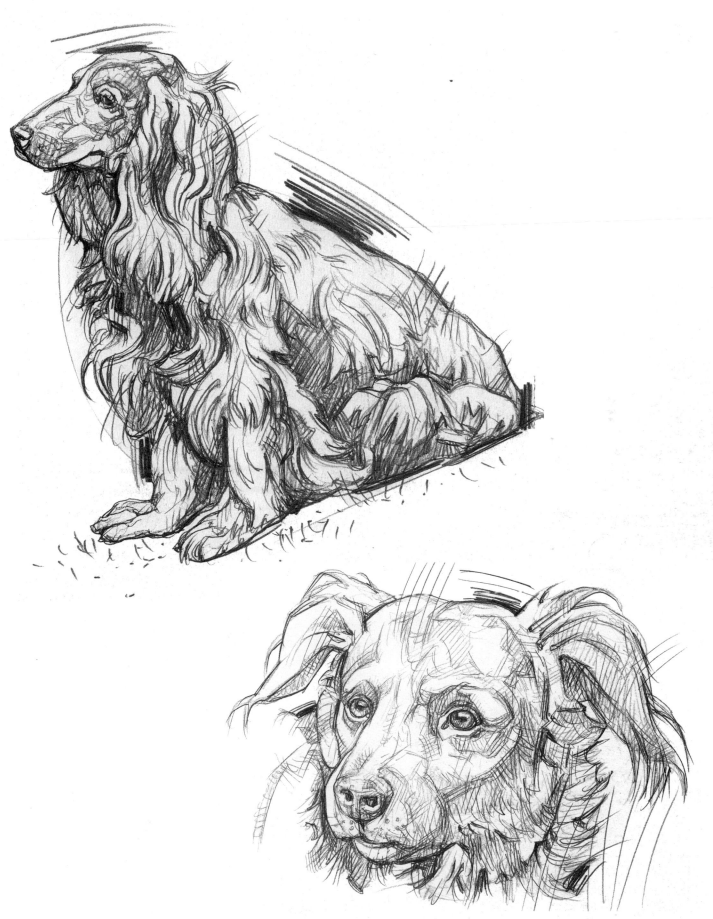

Drawings of short-haired breeds are essentially focused on variations of light and shade, rather than on following the interweavings and patterns produced by the hair. But when a dog has a long, thick coat, it is important to assess the direction in which hairs lie and the places where locks of hair part or come together. Pay particular attention to the underlying anatomical structure, which can still be recognised.

17

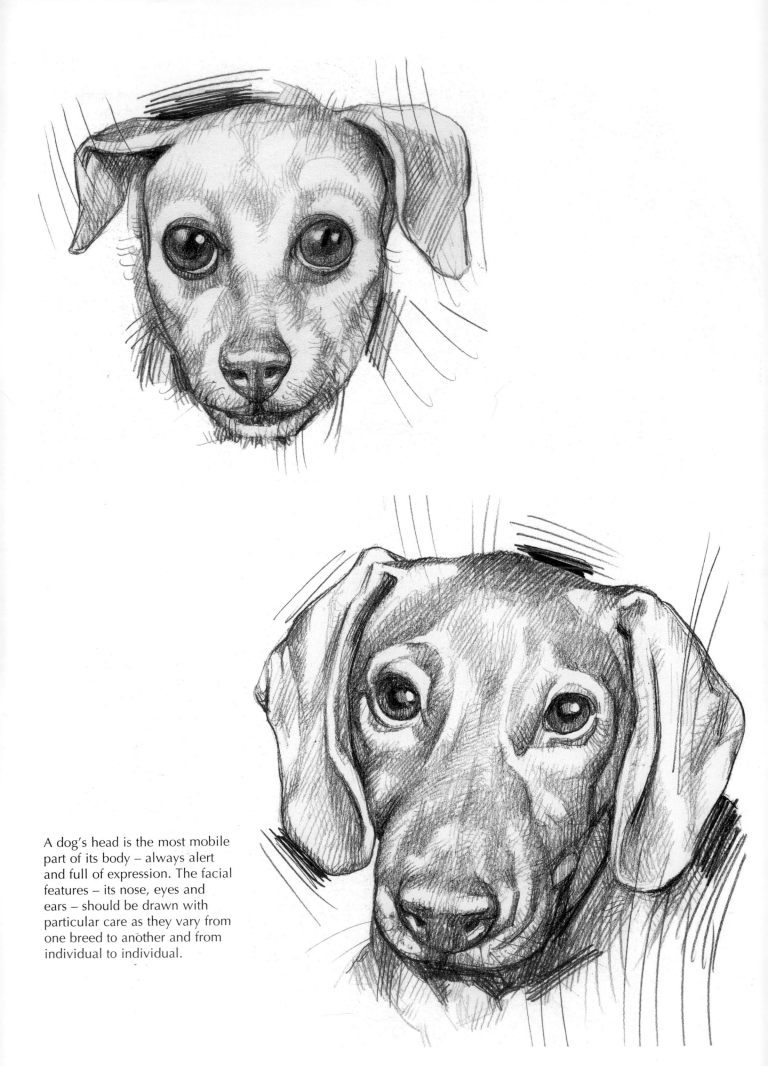

A dog's head is the most mobile part of its body – always alert and full of expression. The facial features – its nose, eyes and ears – should be drawn with particular care as they vary from one breed to another and from individual to individual.

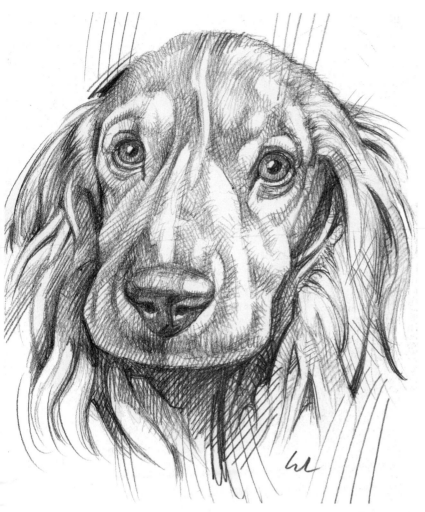

Mouth closed, with the jaws clamped tightly together – this is the way underdogs present themselves to their superiors, a fact worth considering when portraying a dog's head.

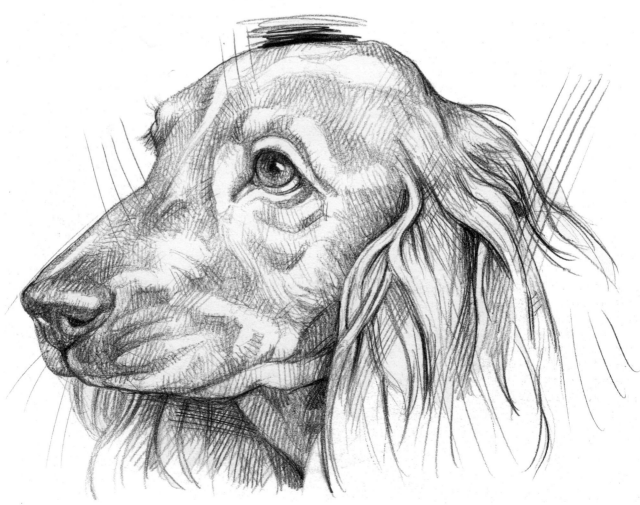

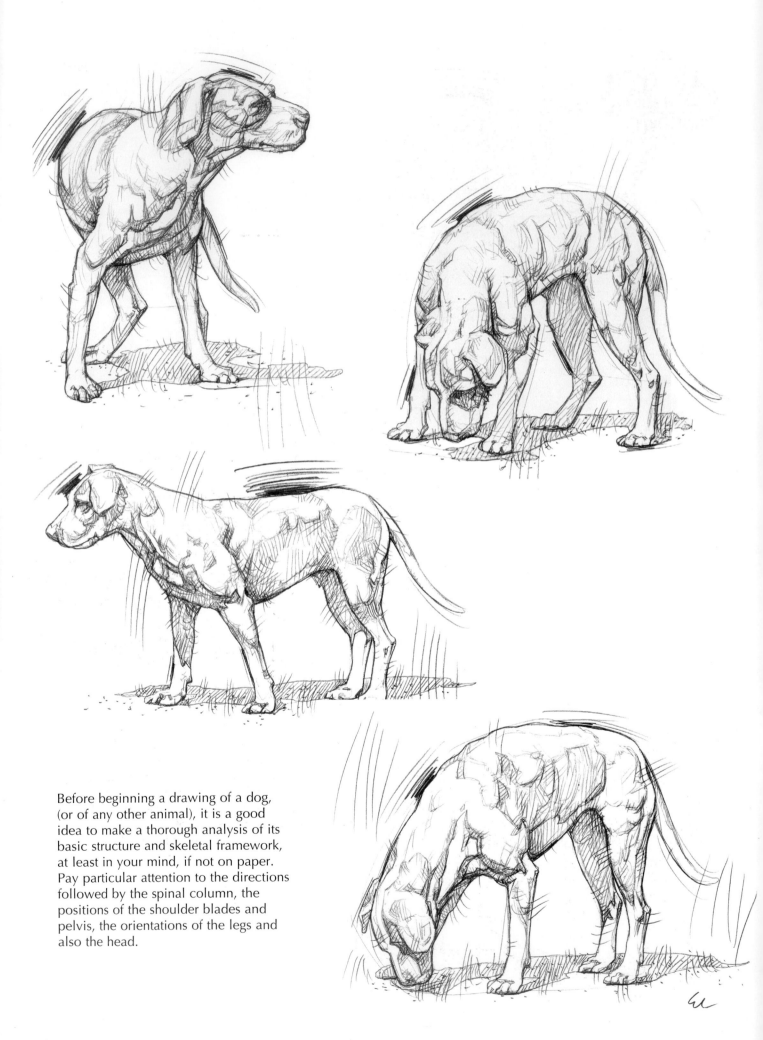

Before beginning a drawing of a dog, (or of any other animal), it is a good idea to make a thorough analysis of its basic structure and skeletal framework, at least in your mind, if not on paper. Pay particular attention to the directions followed by the spinal column, the positions of the shoulder blades and pelvis, the orientations of the legs and also the head.

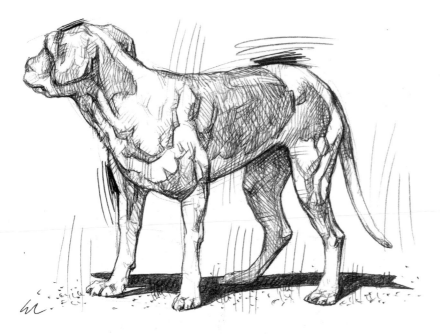

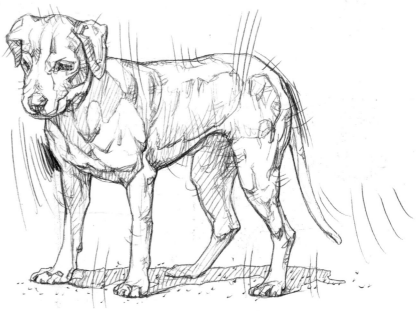

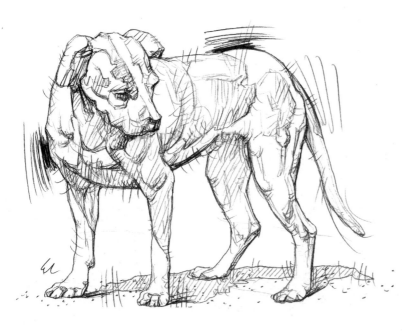

A dog's bone-structure is generally better adapted to rapid, agile movements than to carrying or pulling loads, and accordingly its bones are quite fine and its neck rather short. The back muscles, those of the hips and the limbs are particularly well developed.

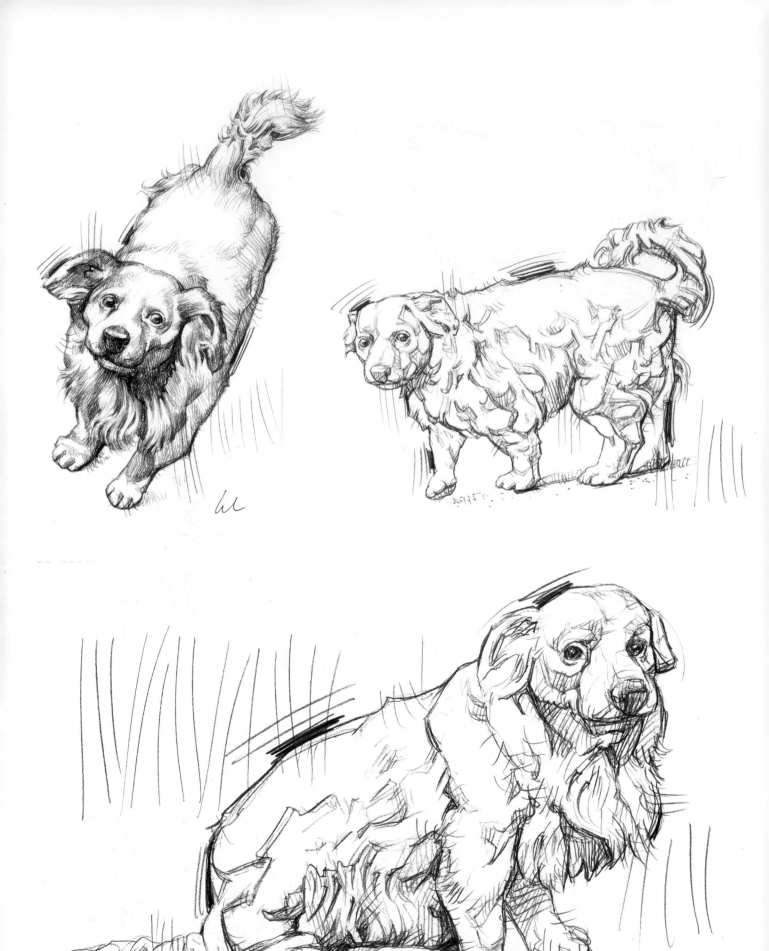

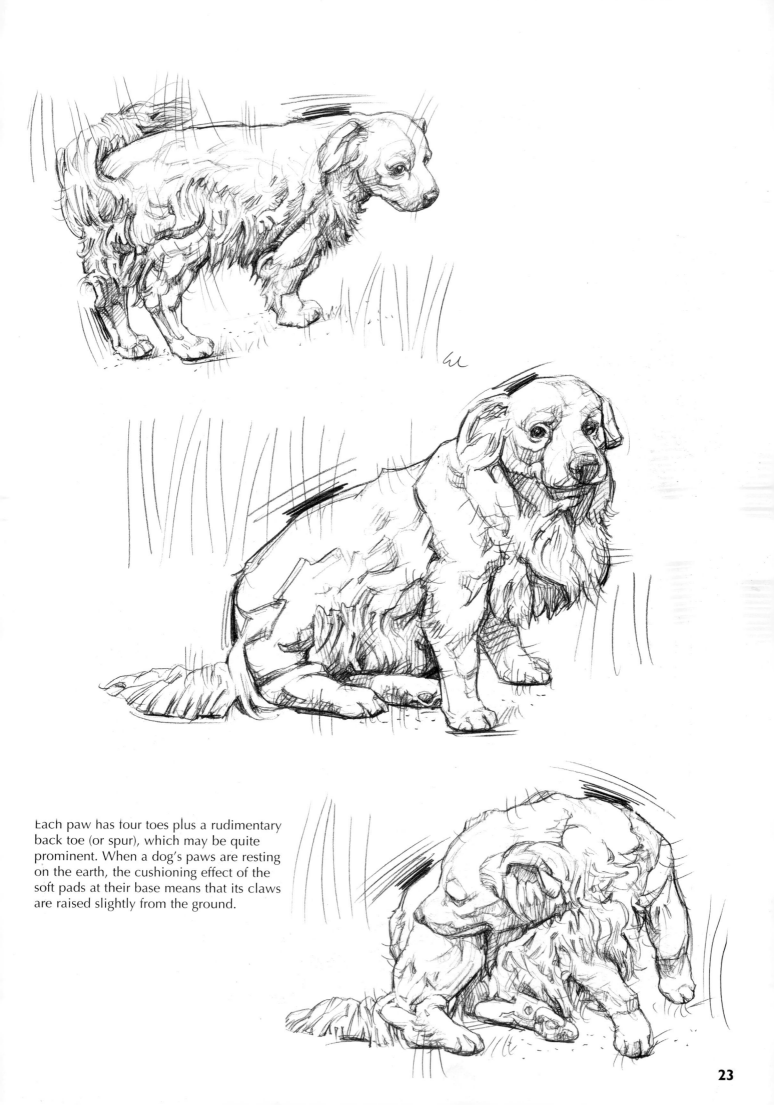

Each paw has four toes plus a rudimentary back toe (or spur), which may be quite prominent. When a dog's paws are resting on the earth, the cushioning effect of the soft pads at their base means that its claws are raised slightly from the ground.

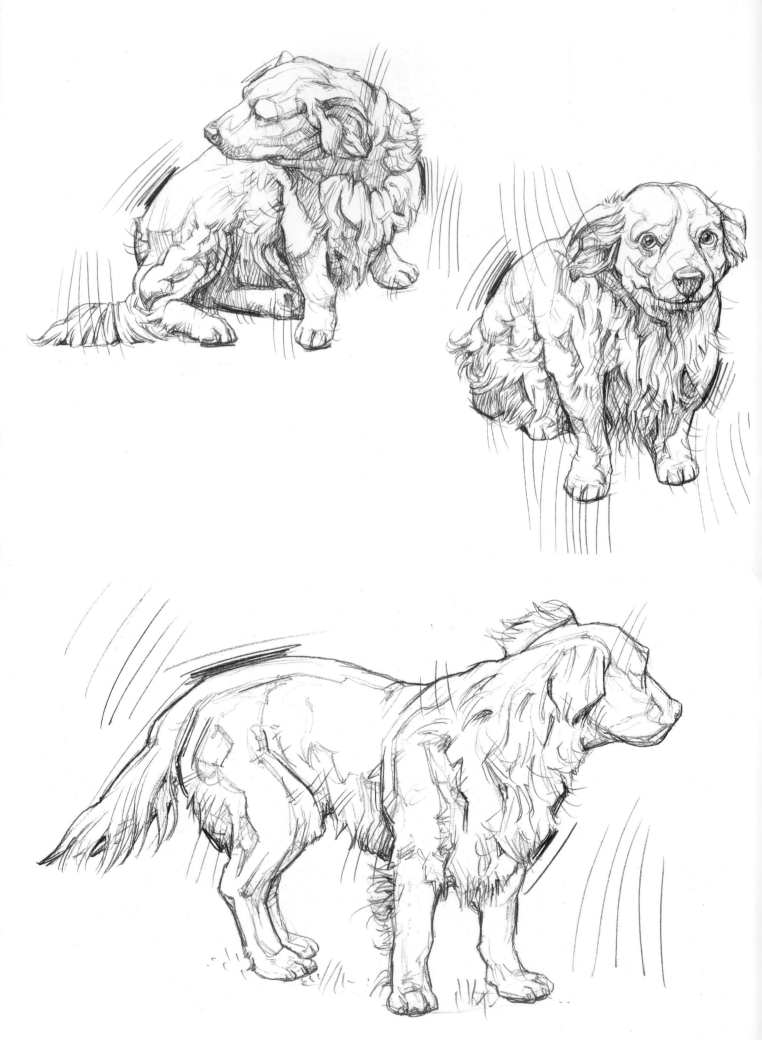

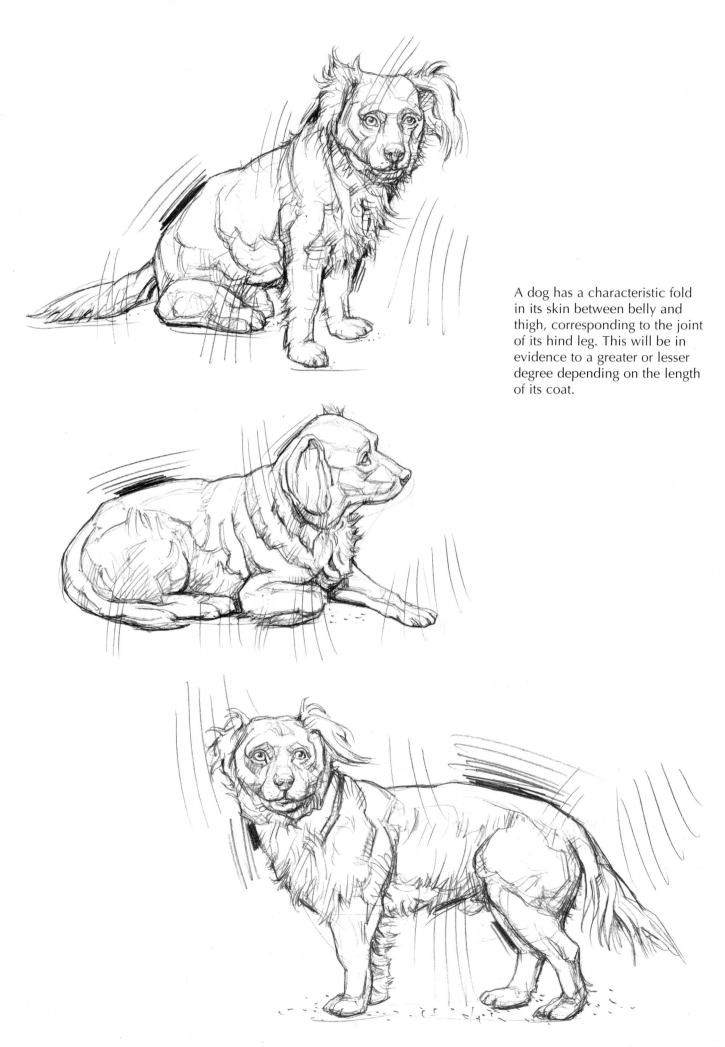

A dog has a characteristic fold in its skin between belly and thigh, corresponding to the joint of its hind leg. This will be in evidence to a greater or lesser degree depending on the length of its coat.

SKETCHBOOK: CHICKENS

Birds are vertebrates adapted for flight. The ovoid shape of their bodies is aerodynamic and their skeletons have also evolved for flight, being very light due to their air-filled bones. The breastbone has the shape of a boat's keel and is fused solid to the collarbones. The muscles are sturdily built and massed around the breast and back, but they are not visible, being completely covered with feathers and down.

There are two main feather types: down feathers, which are small, soft and insulating, and vaned feathers, which cover the body and the down. The remiges (flight feathers of the wing) and rectrices (flight feathers of the tail), are long and rigid vaned feathers, and are laid over the body in overlapping scale-like layers. These flight feathers serve as 'oars' during flight. Of course, when on the ground, birds walk on their hind limbs, as the front ones have evolved into wings.

There is a long tradition of the patient study of birds, which now uses the camera as its tool of choice. This has supplied us with a vast and highly useful stock of reference images, but in this small section I have limited myself to drawing the chicken, or domestic fowl. I have done so because it is relatively simple to find examples of these birds in the countryside. On poultry farms, behind fenced enclosures, the hens, cockerels and chicks rummage about for food, and it is not difficult to single out an attractive specimen and draw it while this semi-flightless bird is busy pecking at food and scratching the soil. There is little variation in a chicken's behaviour, and the birds soon get used to the presence of a strange person on their territory. Apart from chickens, other domesticated birds that provide similarly compliant models, such as geese, swans and ducks, can be studied in their countryside habitats or in the ponds of city parks.

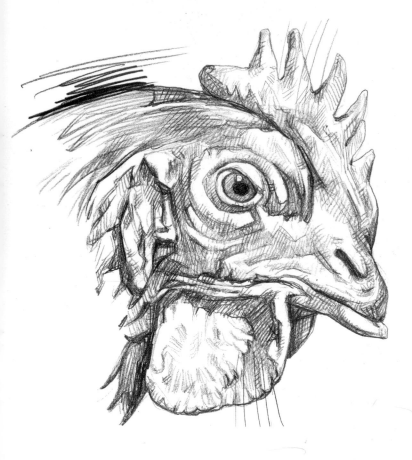

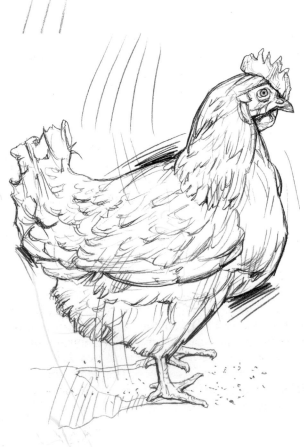

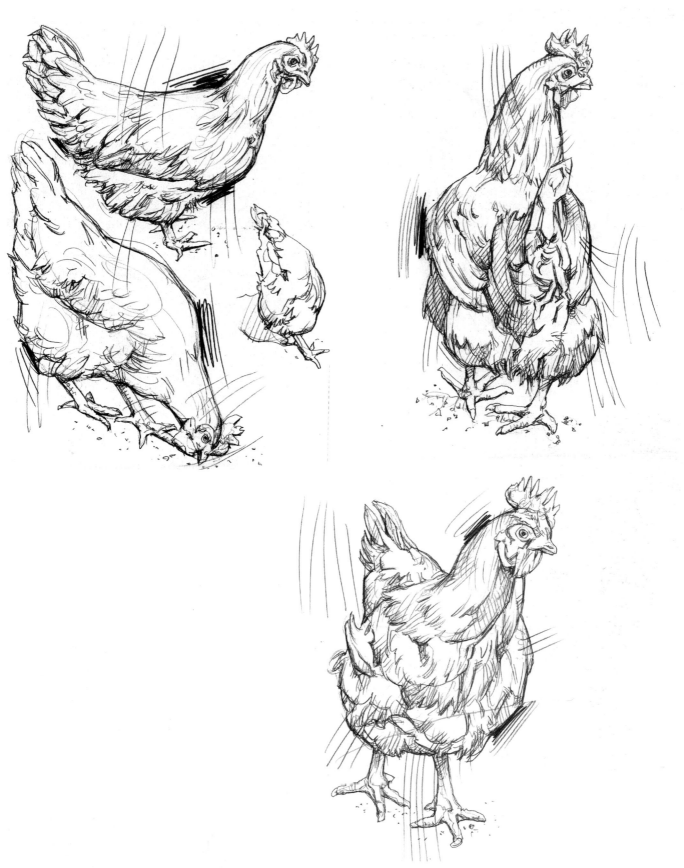

The plumage of the cockerel, or rooster, tends to be boldly coloured: his head is decorated with a large comb on top, with wattles below the beak; his feet are equipped with spurs – a horny conical growth pointing upwards from the back of the foot above the fourth toe. The hen is smaller and weighs less than the cockerel of the same species; her comb is usually more modest, or sometimes completely absent, and her wattles are often less developed. In both sexes, the eye has a flattened, lenticular shape and is set in the side of the head; there is no external ear and the auditory canal is covered over by feathers and folds in the skin; each foot has four toes: three pointing forwards and spread out fan-wise, and one backward-facing. The toes are armed with sharp claws and have a covering of scaly skin.

SKETCHBOOK: CATTLE

The term 'cattle' is generally used to refer to domesticated bovines raised for milk or meat production. The castrated males, especially those used as beasts of draught, are widely known as oxen, the male of the species is called a bull, the female is a cow and the young animal is a calf. Cattle have long been used as beasts of draught and utility for human populations in an association that reaches back to remote antiquity. Bovines are artiodactyla (even-toed); they are ruminants (regurgitating semi-digested food – the cud – to chew it a second time) and ungulates (hoofed animals), having two toes on each cloven, conically shaped hoof. They are ponderous, massive animals whose build is better adapted to steadiness than to fleetness of foot. The trunk of the body has the shape of a flattened cylinder, and the head is large and pyramidal in shape with a long muzzle.

Cattle have forward-pointing horns that are present throughout the year and whose length varies with breed. Their necks are particularly sturdy and, together with the back, give the animal a continuous, horizontal and straight upper profile, although in some species this line is interrupted by a hump. Cattle are easy to draw because they rarely make sudden movements or engage in energetic behaviour, preferring to spend most of their time with their heads to the ground, intent on grazing.

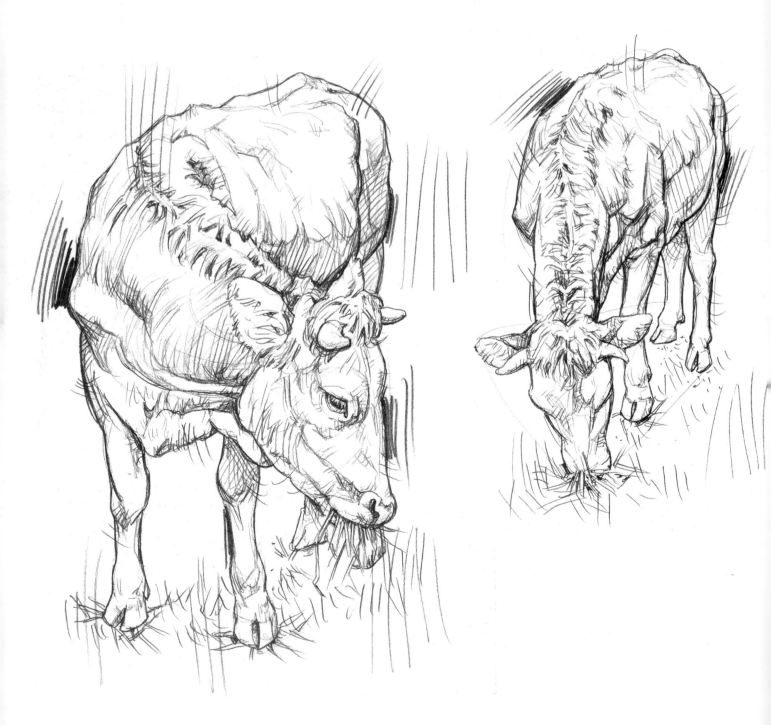

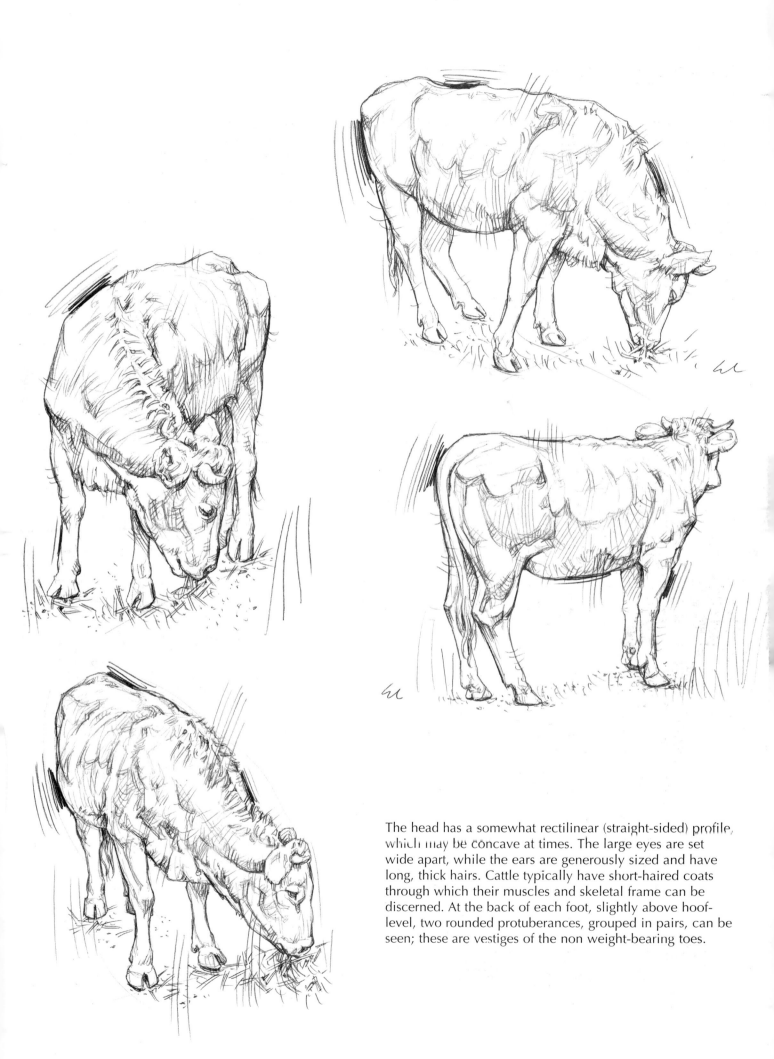

The head has a somewhat rectilinear (straight-sided) profile, which may be concave at times. The large eyes are set wide apart, while the ears are generously sized and have long, thick hairs. Cattle typically have short-haired coats through which their muscles and skeletal frame can be discerned. At the back of each foot, slightly above hoof-level, two rounded protuberances, grouped in pairs, can be seen; these are vestiges of the non weight-bearing toes.

SKETCHBOOK: CATS

Everybody knows what a large variety of cat breeds there are, and we are all familiar with the supple, nimble movements and the dignified independent character of the domestic cat. But despite their capacity for swift movement, cats will often assume placid, static poses and hold them for long periods. Cats love to sleep curled up in a ring, or splayed out on one side; they may often become engrossed in grooming themselves or in intently observing their environment while sitting neatly on their hind legs. They also enjoy toying with small objects. These are moments during which you will be able draw a cat in an unhurried way. It is the cat's lightning-fast dynamism that attracts our attention the most and which displays the greatest variety of movement. This aspect can only be captured in brief, bare sketches and the best strategy here is to focus on observing the way the animal's actions develop in real time – such movements may often be repetitive ones – and then to get the sketch down on paper after the event, trying to retrace the entire action sequence. Of course, you can make use of photography for this purpose and, indeed, this may even prove indispensible, or you can freeze-frame sequences from films or documentaries. However, if you do this, beware of making an overly detailed drawing as this can make the image appear static and can rob the movement of its vitality and flow.

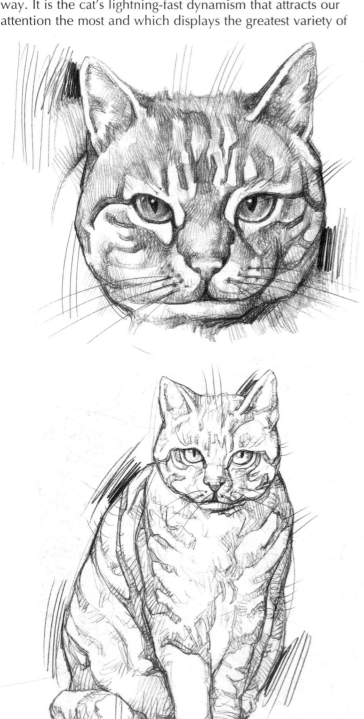

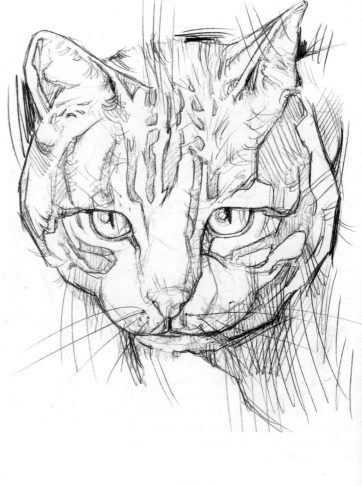

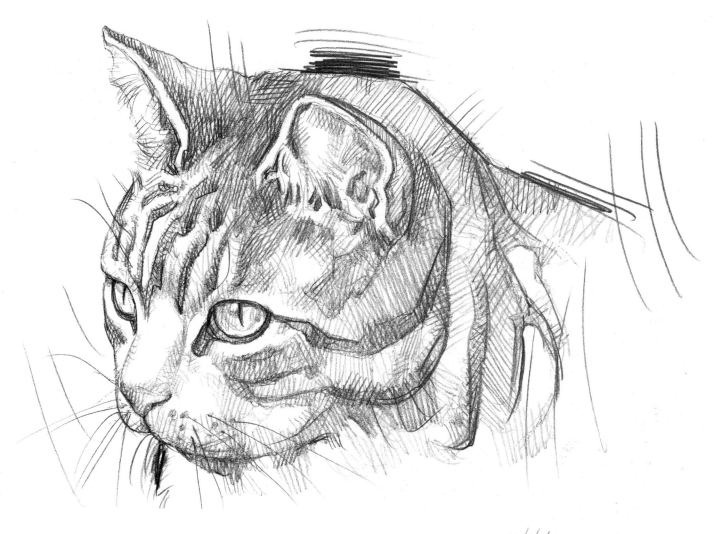

NOTABLE FEATURES

As well as the cat's whiskers on each side of its nose, other extra-long, stiff hairs also grow on the cat's face above its eyes and in front of its ears. These long hairs, including the whiskers, are technically known as *vibrissae* and function as organs of touch. The cat's outer ears (or *pinnae*) have a concave, triangular shape and are extremely mobile and velvety in texture. Cats have long, curved canine teeth, which are conical in profile and also very sharp. The pupil of the eye opens to a full circle in complete darkness but in the presence of light it closes to a vertical slit, which narrows as the light intensifies. When a cat is ill or out of sorts, the 'third eyelid' (the nictitating membrane) will cover part of the eyeball.

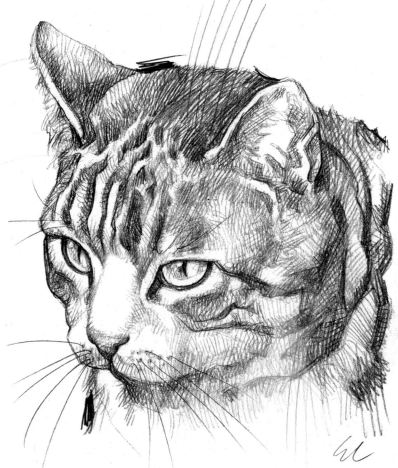

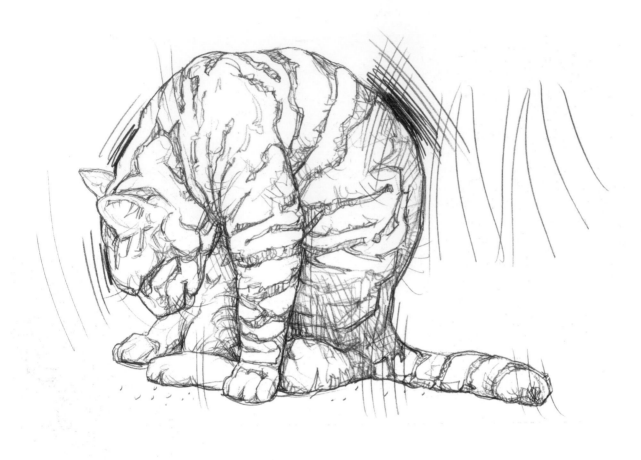

UNDERSTANDING THE STRUCTURE

Cats have small heads with a short face, but their bodies are elongated. It is difficult to discern clues to the build of their muscles and their skeletal framework as these are hidden beneath a thick coat of hair. It is often only through the delicate play of light on surface planes, or by means of the wave patterns of an animal's stripes, that the underlying structures may be recognised and their volumes indicated in the drawing. Concentration is required to draw the bodily structure of a cat in its correct proportions.

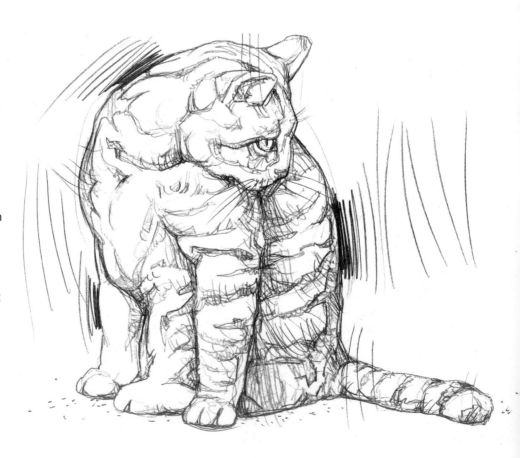

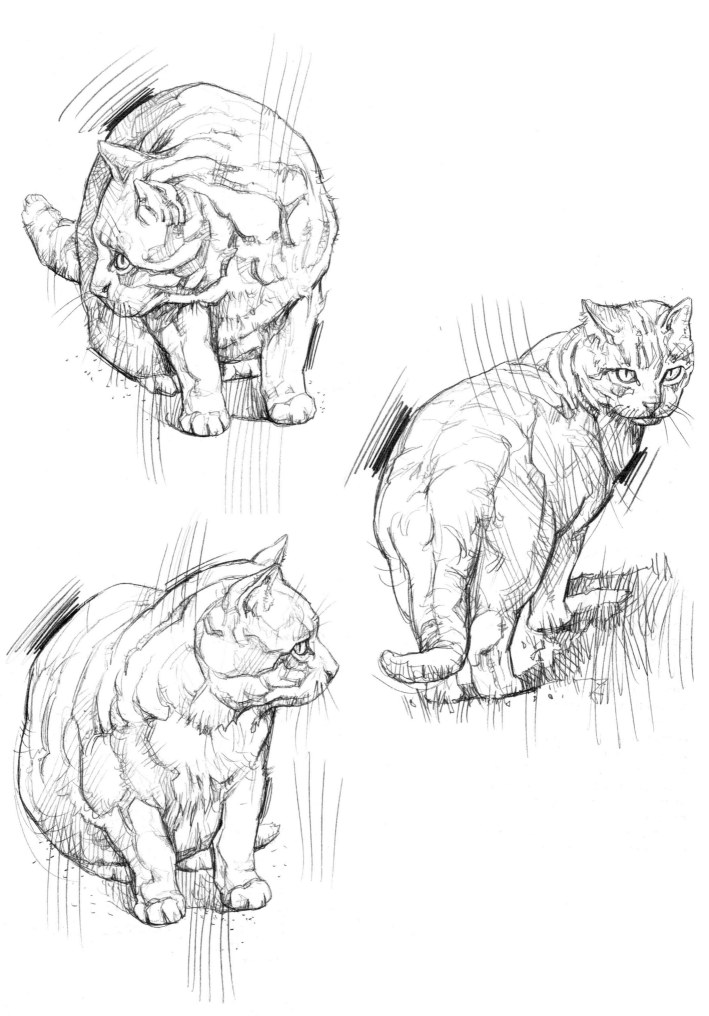

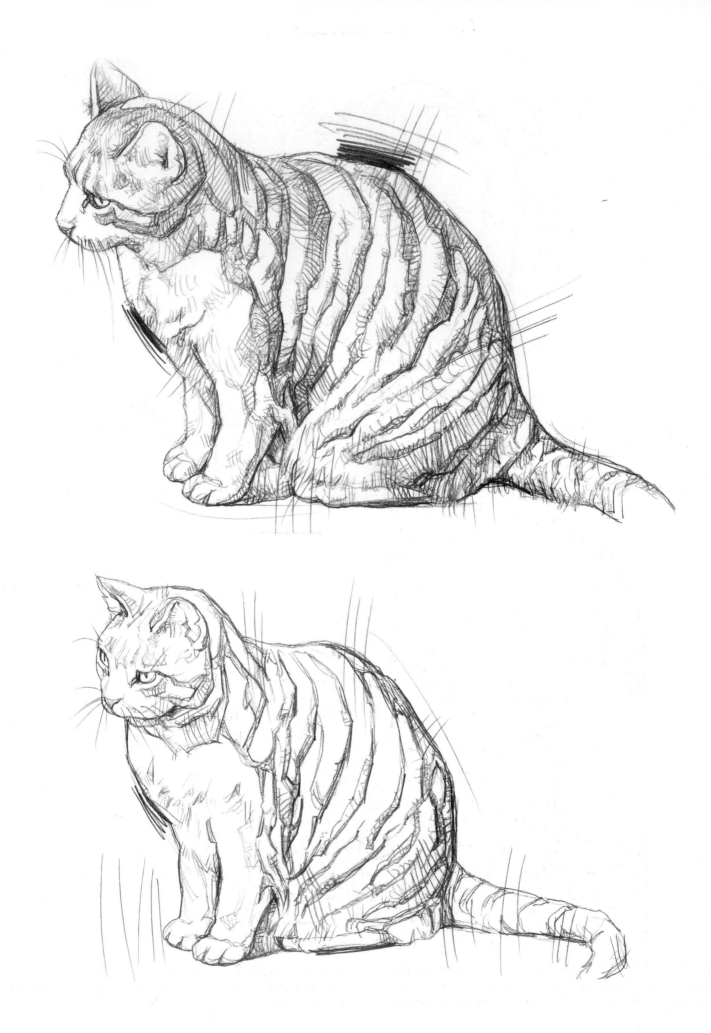

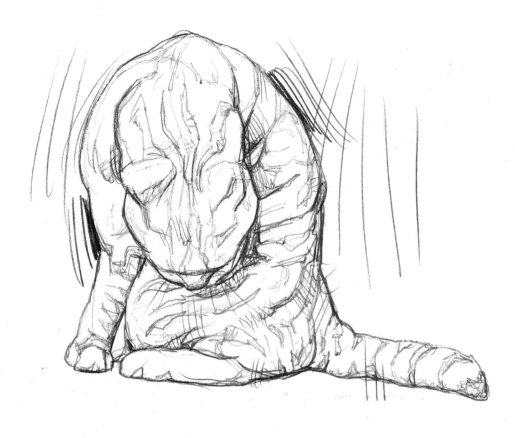

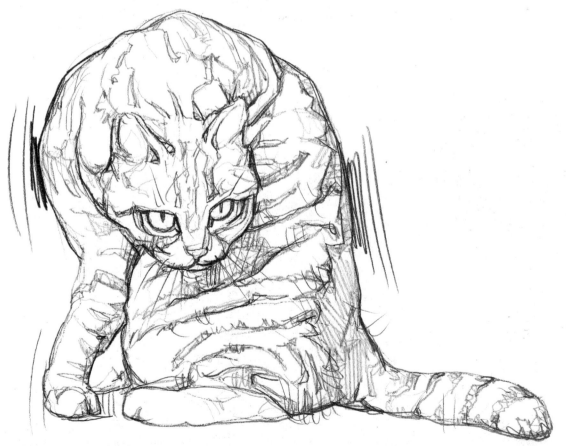

A cat's body is very supple and its limbs are adapted for quick pounces and unexpected springs, for running and for climbing. Soft pads give its paws their steady footing and a soft, silent tread. A cat's strongly fashioned, curved claws are retractable, and are exposed voluntarily when required for assault, for climbing or for clinging, for example.

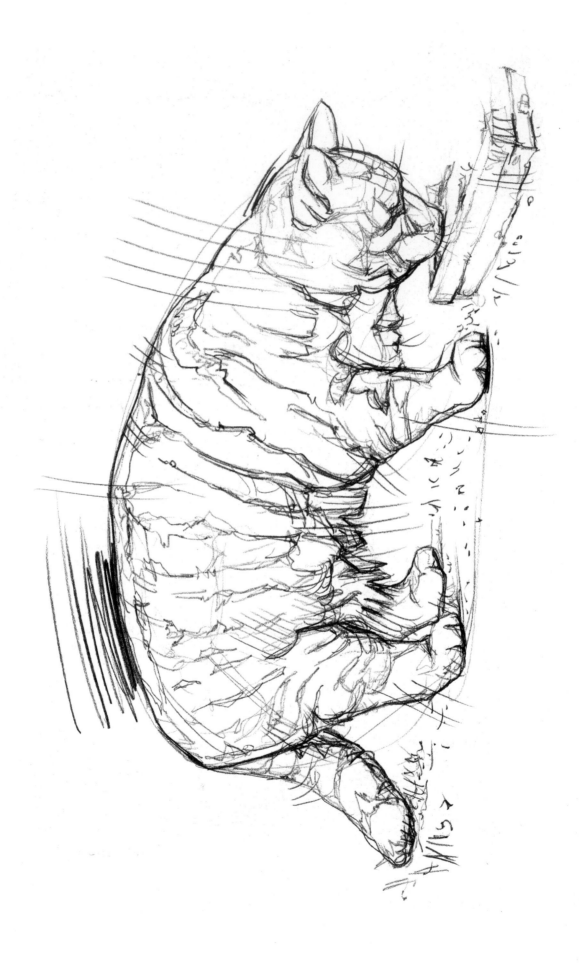

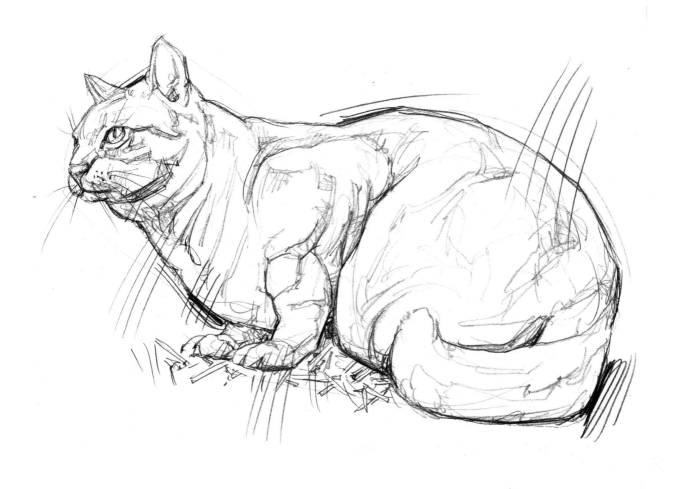
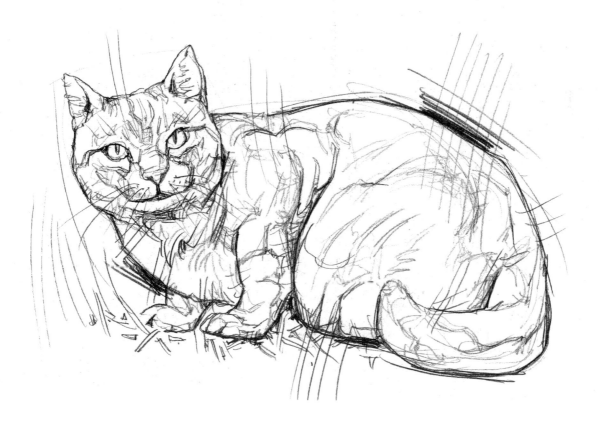

SKETCHBOOK: HORSES

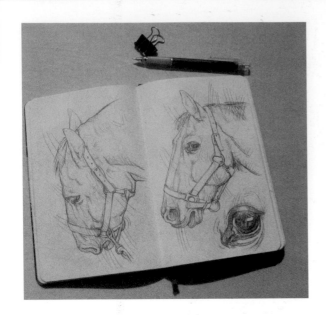

In this and the following section, I would like to present some pages from my sketchbooks. The practice of keeping sketchbooks is indispensible for keeping your hand well trained for drawing. As the Ancients said: '*nulla die sine linea*' (never a day without a line), and a small notebook for visual note taking is something that should accompany an artist wherever he goes. Sketching from life will sharpen your observational capacities, help you to notice interesting details and at the same time teach you fluency of line. You will also assemble a stock of visual records that you can call on when attempting more highly finished work.

The following sketches were made over a period of months during which I was an unfailing visitor to certain stables and riding schools. A degree of discomfort had to be endured in terms of working conditions, but this was more than compensated for by my pleasure in the work. Horses are such beautiful and fascinating creatures and they fully deserve a course of study in their own right, (one which I hope to undertake in a forthcoming book). Here, I shall limit myself to putting my visual notes on display in the hope that they will stimulate other artists to imitate my habit – and passion – for keeping life-study sketchbooks.

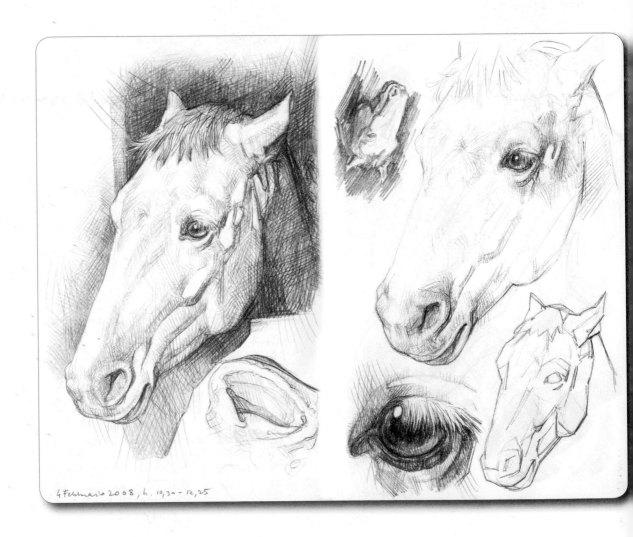

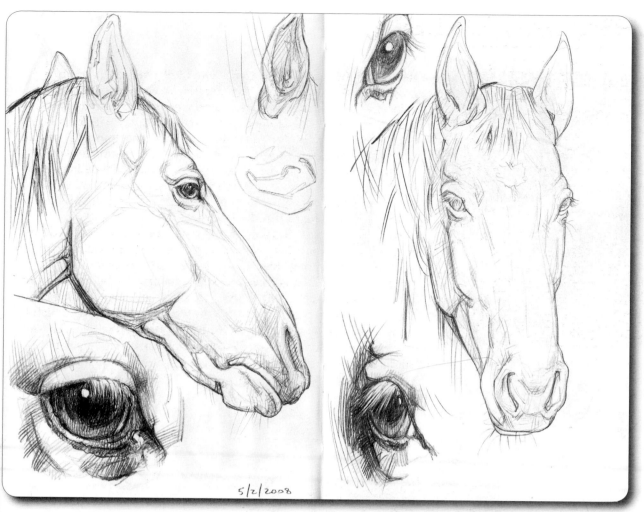

5/2/2008

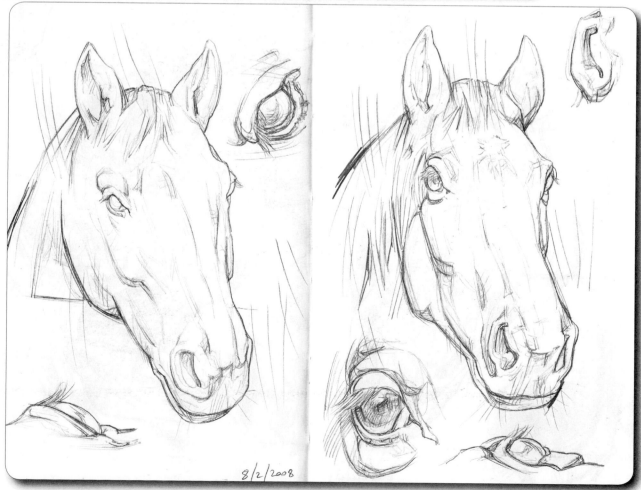

8/2/2008

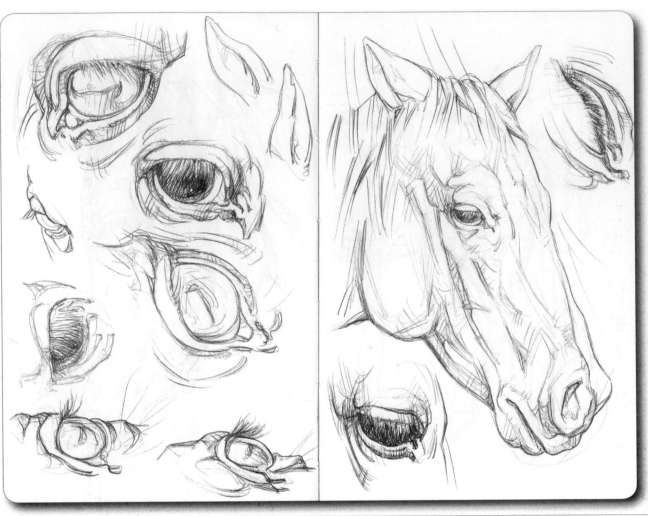

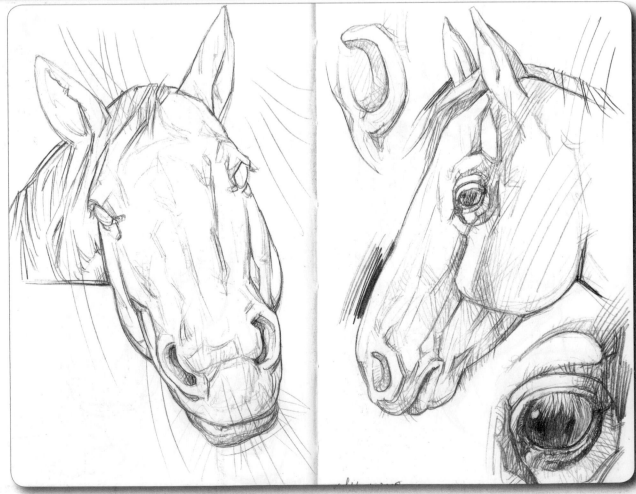

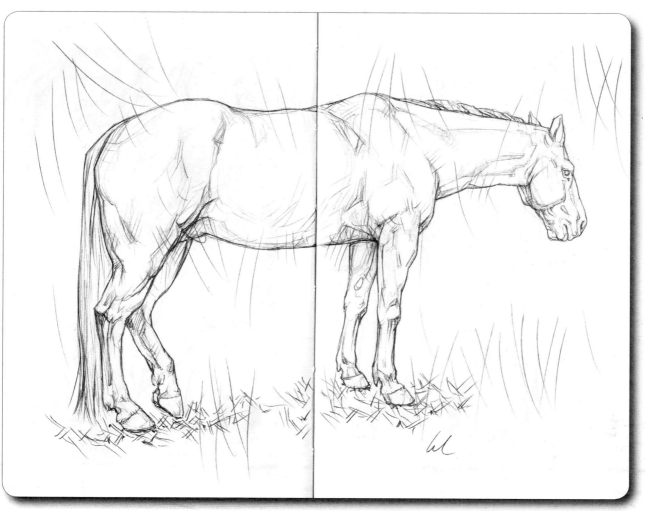

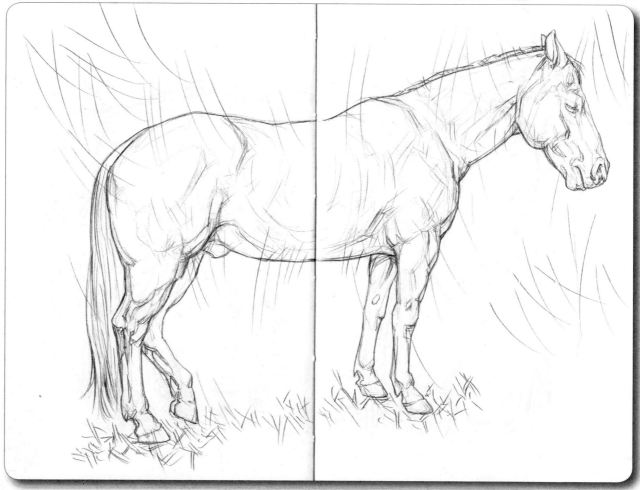

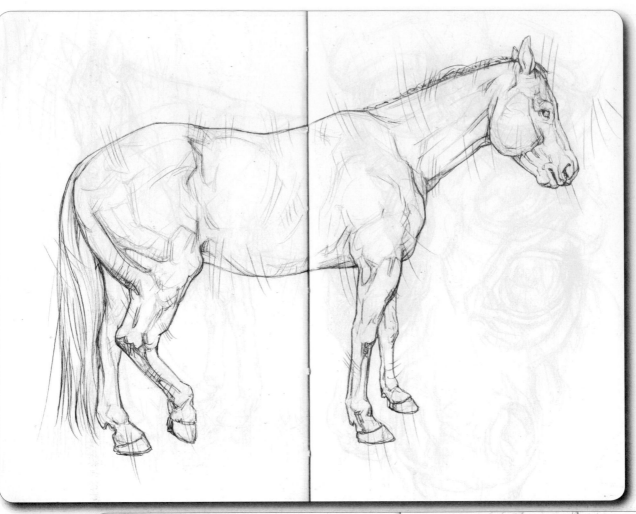

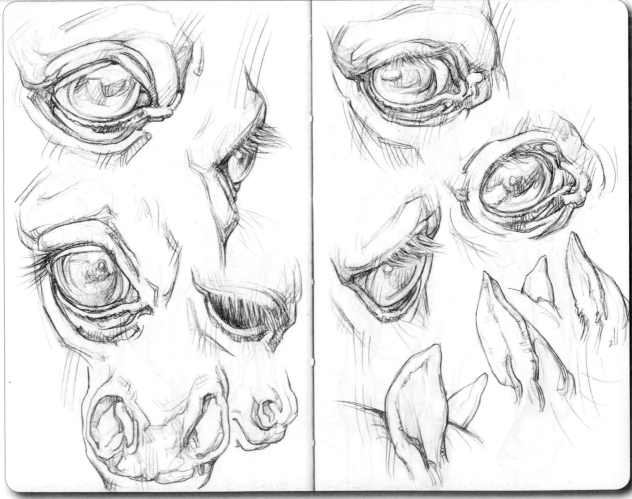

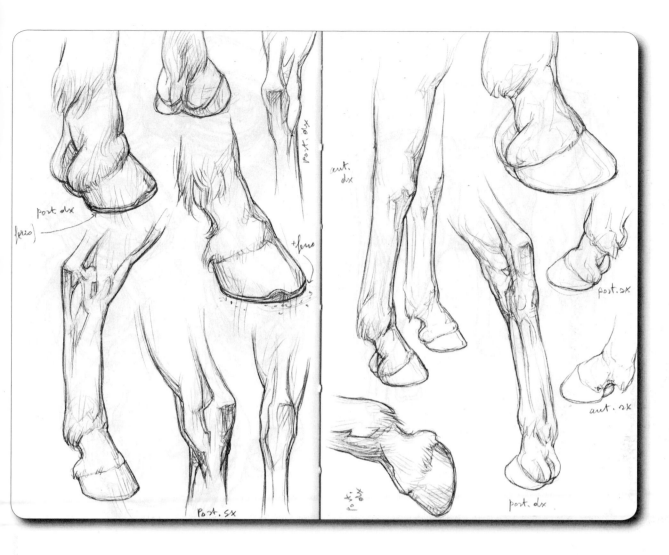

post dx

(piede)

post dx

+ferro

aut. dx

post. sx

aut. sx

Post. sx

post. dx

post. dx

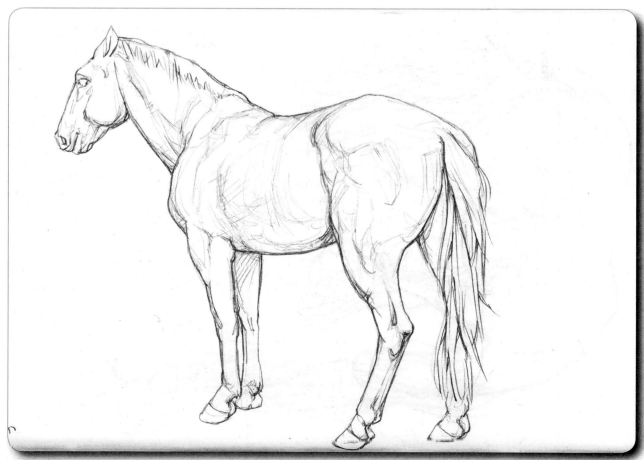

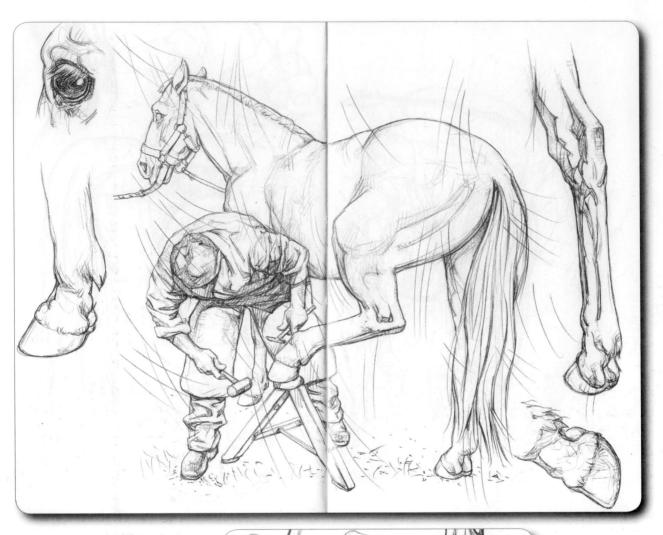

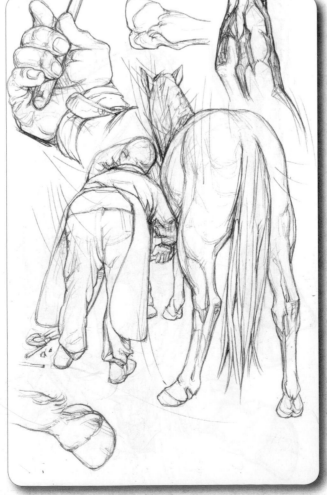

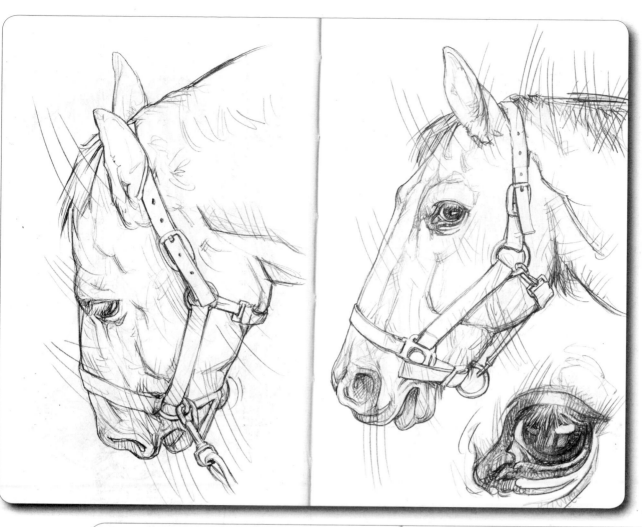

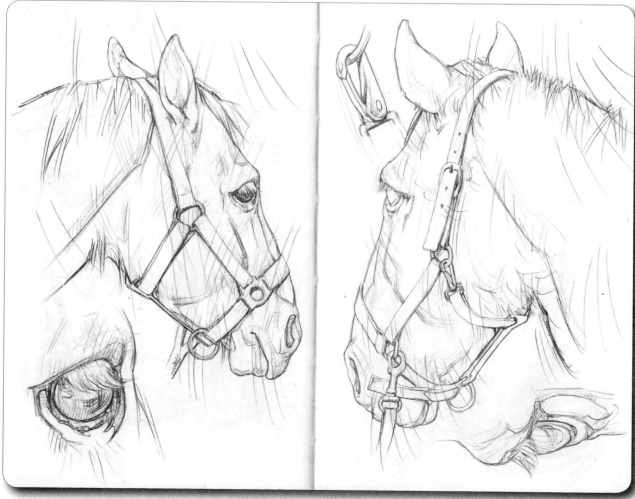

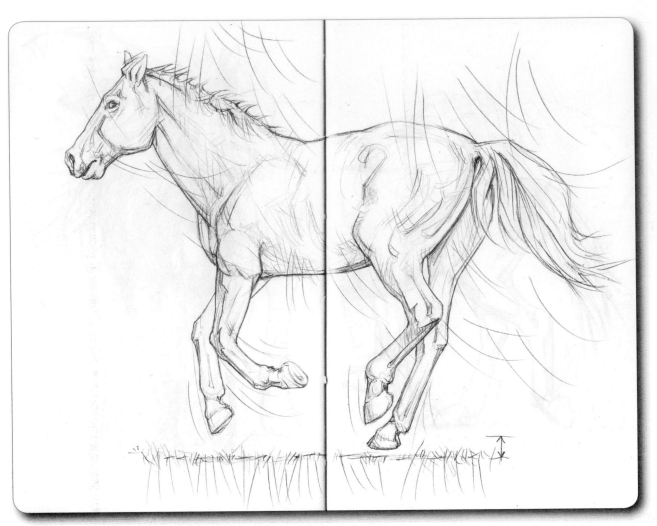

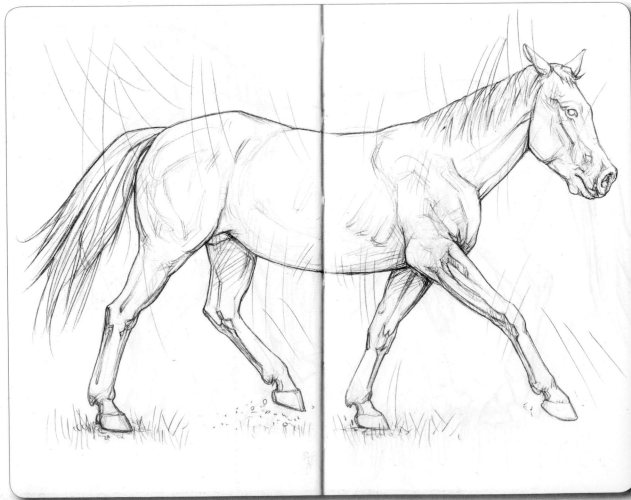

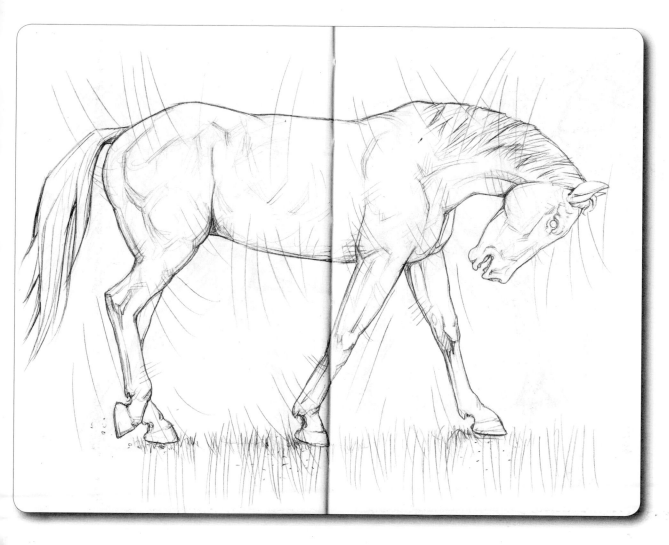

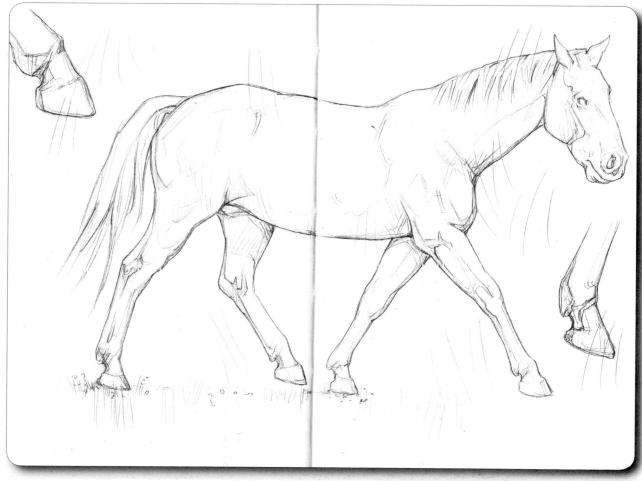

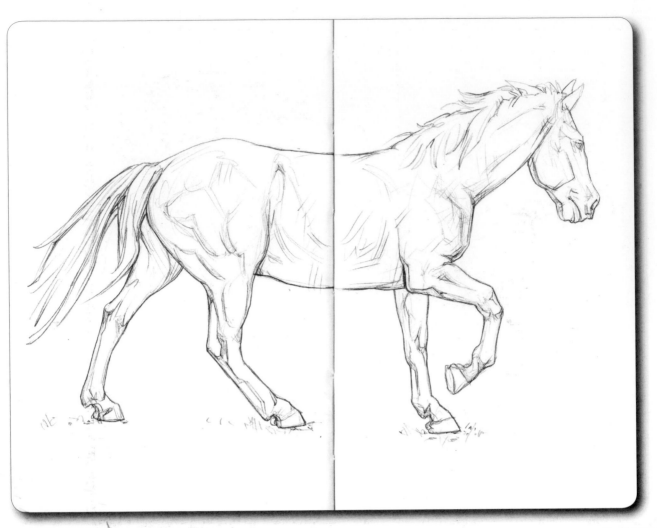

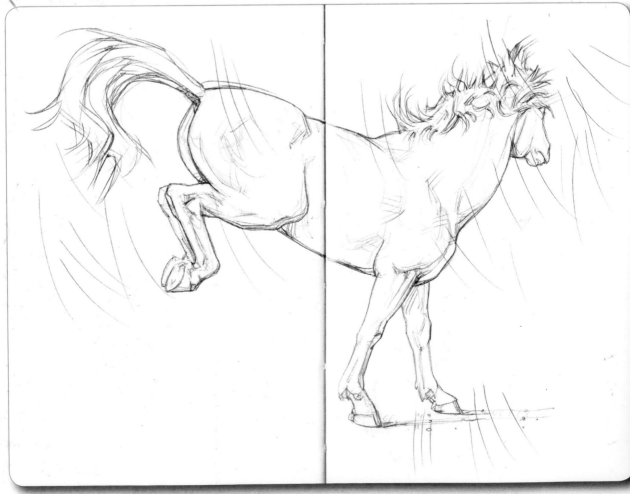

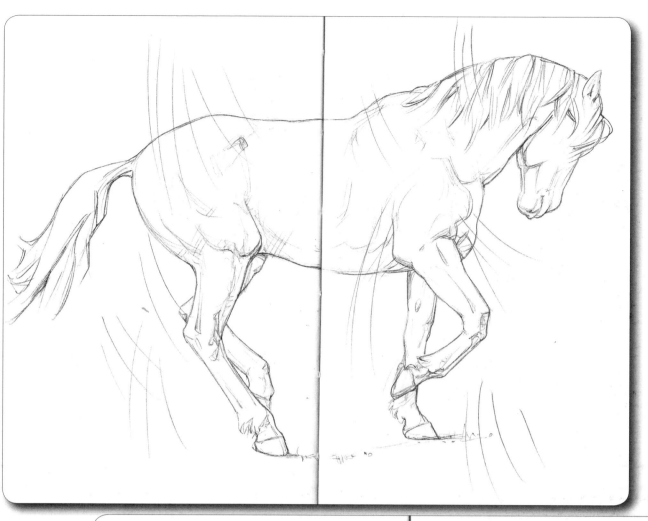

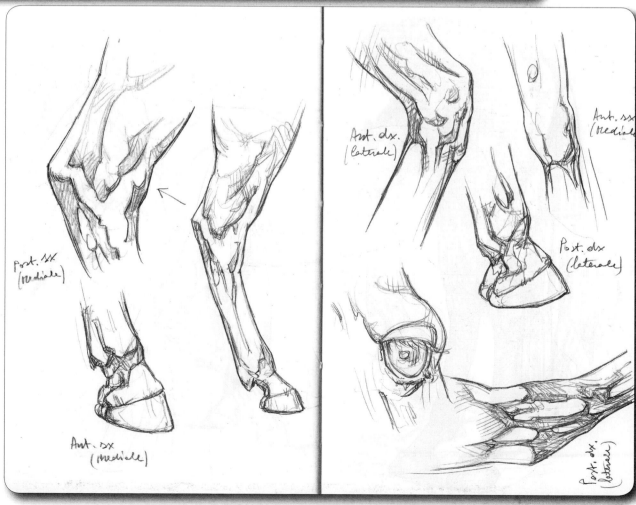

Post. sx
(mediale)

Ant. dx.
(mediale)

Ant. dx.
(laterale)

Ant. ss
(mediale)

Post. dx
(laterale)

Post. dx.
(laterale)

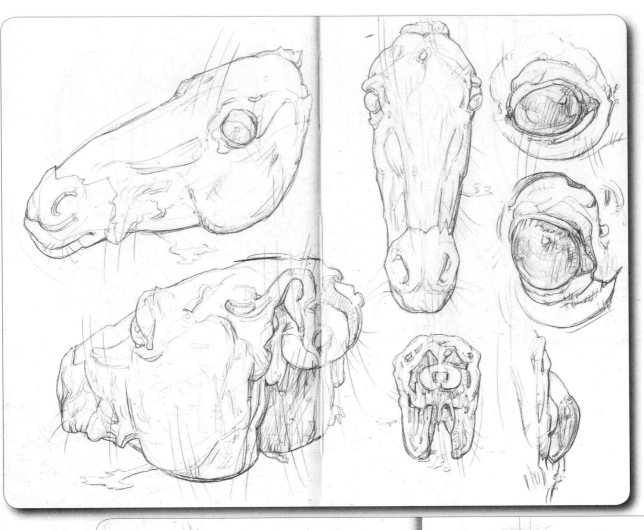

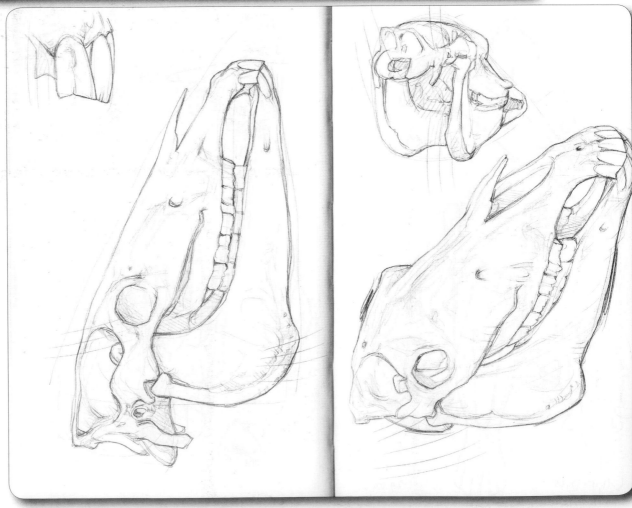

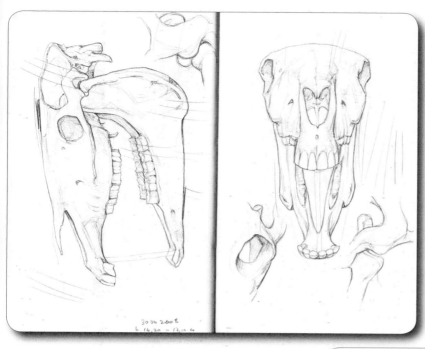

30 VIII 2008
L 14,20 - 17,10 a

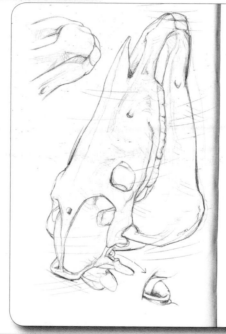
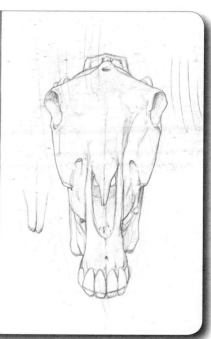
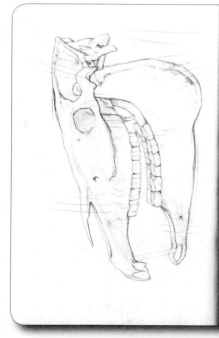
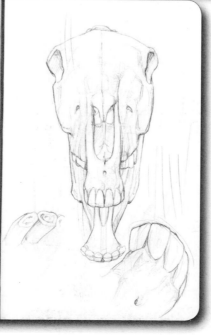

WILDLIFE SKETCHBOOK

(Drawings from the Natural History Museum, Milan)

In this final section, I would like to show a few pages from another one of my sketchbooks. We do not often get the opportunity to draw wild or exotic animals from life, and this is the reason why I have limited myself so far in this book to drawing only some of the more common domestic animals. But natural-history museums, which can be found in many larger cities, offer another great opportunity to the artist. In these museums, animals are displayed according to strict scientific and didactic criteria, having undergone a complex process of taxidermy. This work is usually performed by highly competent and qualified experts so that the preserved animals are displayed in a very faithful manner that is as true to nature as possible. Ideally, it would be useful to follow up your depiction of these examples with a study made of the animal in the wild, incorporating its habitats and its typical behaviour, or you could perhaps refer to the wildlife studies of experts. Even without this, time spent sketching in a natural-history museum can be a significant exercise in its own right, as it allows you to examine the whole animal from close up and to note even the tiniest of details.

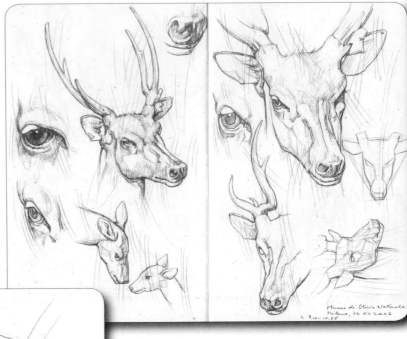

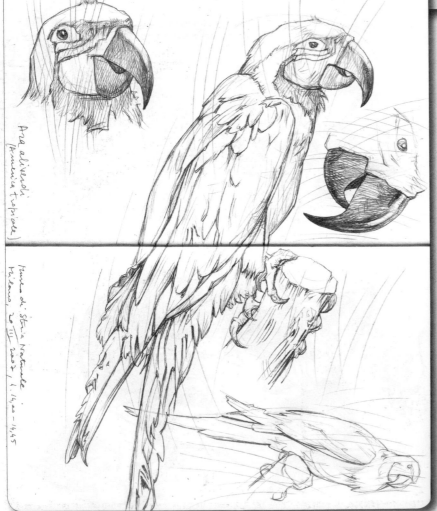

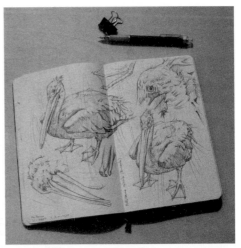

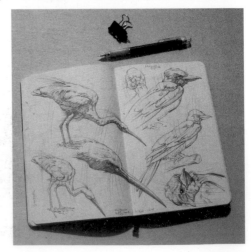

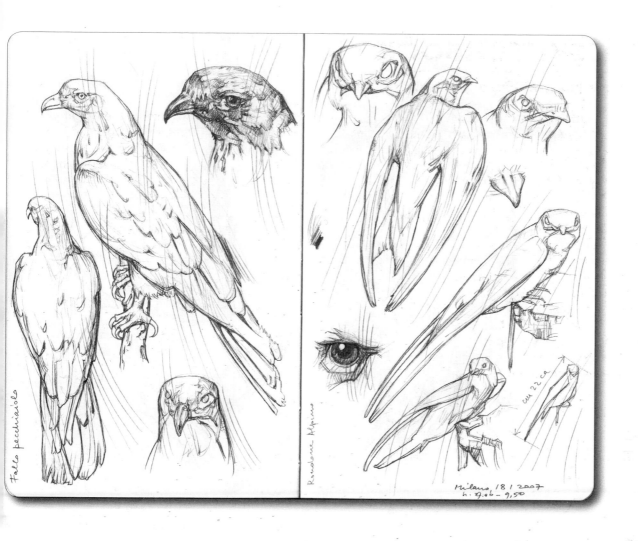

Falso pecchiaiolo

Rondone Alpino

cu 22 ca

Milano, 18 I 2007
h. 9.06 – 9,50

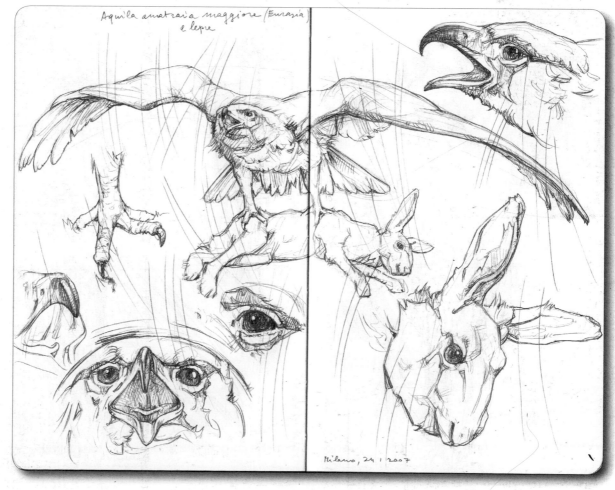

Aquila anatraia maggiore (Eurasia)
e lepre

Milano, 24 I 2007

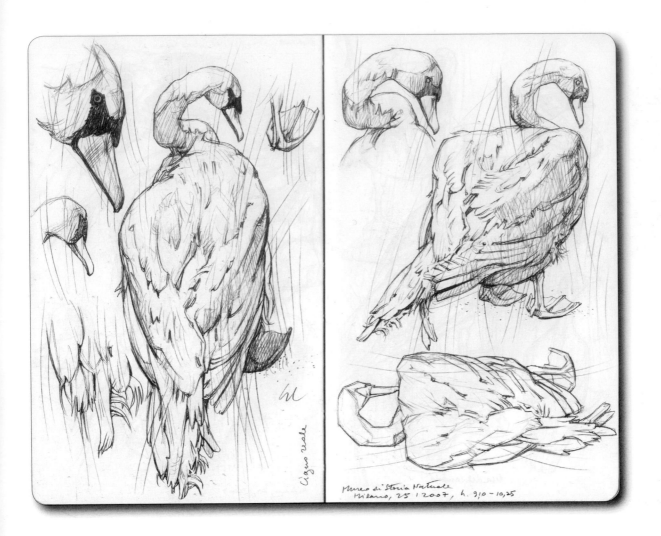

Museo di Storia Naturale
Milano, 25 I 2007, h. 9,0 – 10,25

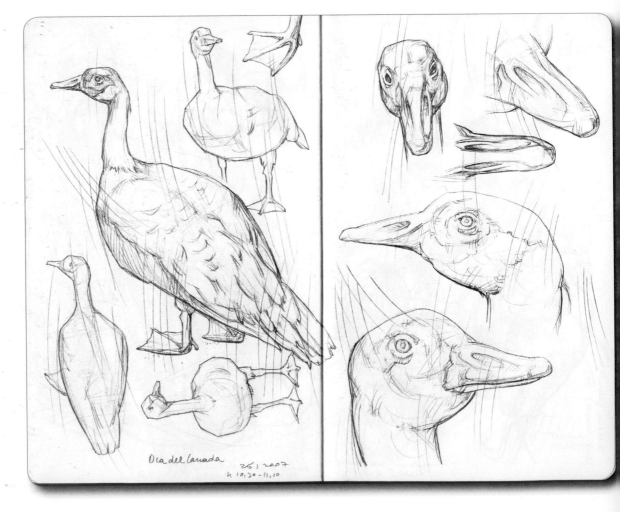

Oca del Canada 26 I 2007
h 10,30 – 11,10

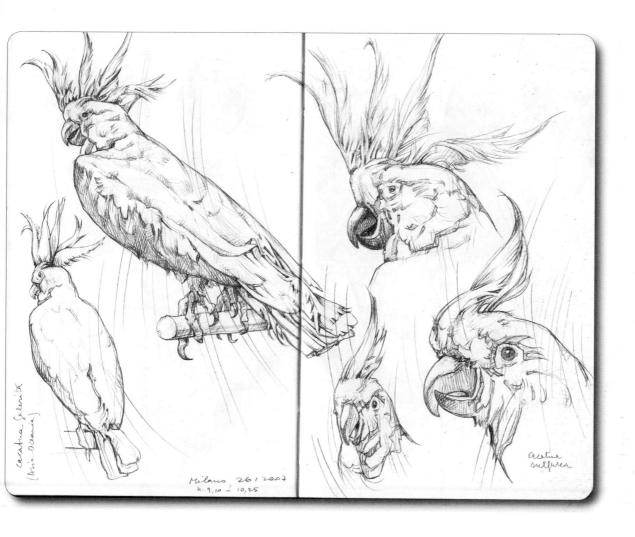

Cacatua galerita
(Aria Oceania)

Milano 26 1 2007
h. 9,10 - 10,25

Cacatua
sulfurea

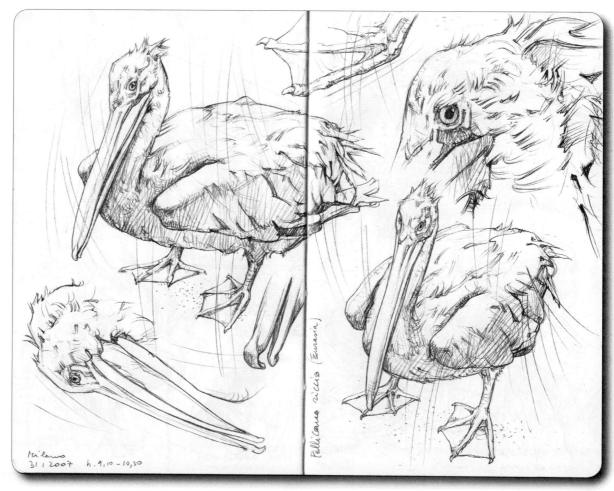

Milano
31 1 2007 h. 9,10 - 10,30

Pellicano riccio (Eurasia)

55

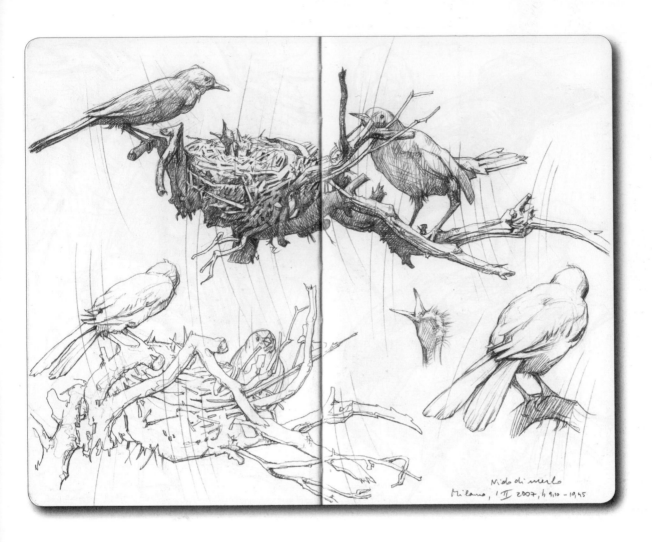

Nido di merlo
Milano, 1 II 2007, h 9,10 - 19,45

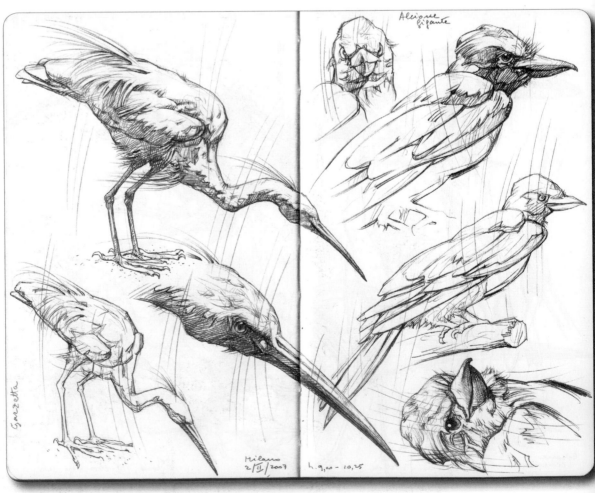

Alcione gigante

Garzetta

Milano
2/II/2007 h 9,00 - 10,25

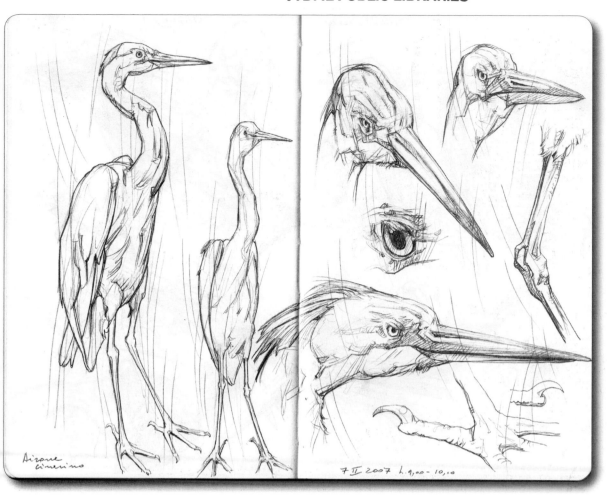

Airone
cinerino

7 II 2007 h.9,00 - 10,10

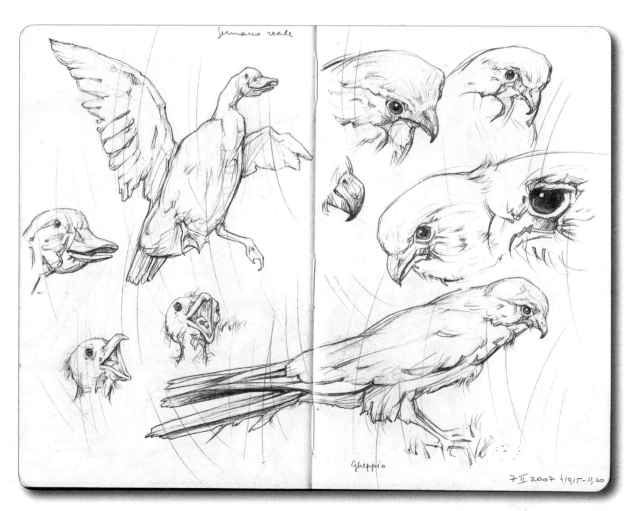

Germano reale

Gheppio

7 II 2007 h10,15 - 11,20

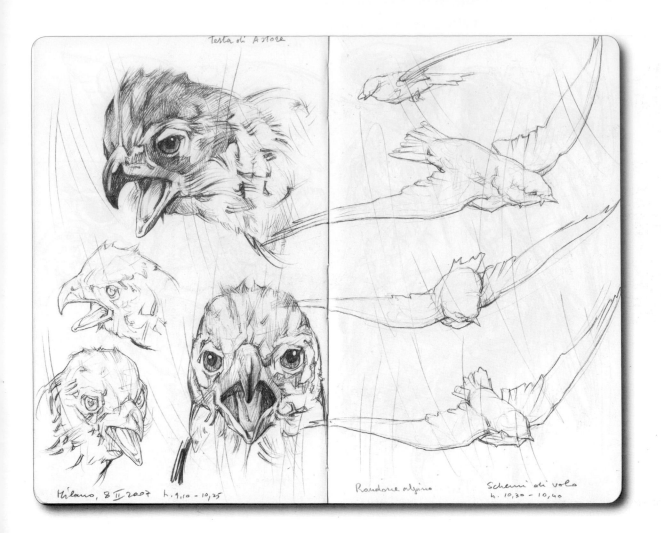

Testa di Astore

Milano, 8 II 2007 h. 9,10 - 10,25

Rondone alpino

Schemi di volo
h. 10,30 - 10,40

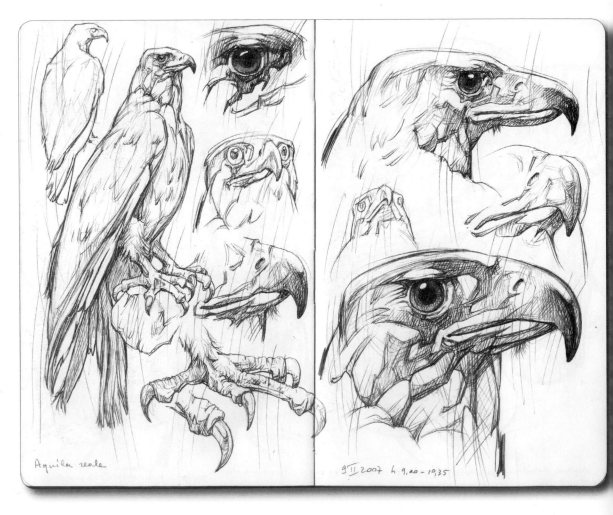

Aquila reale

9 II 2007 h. 9,00 - 10,35

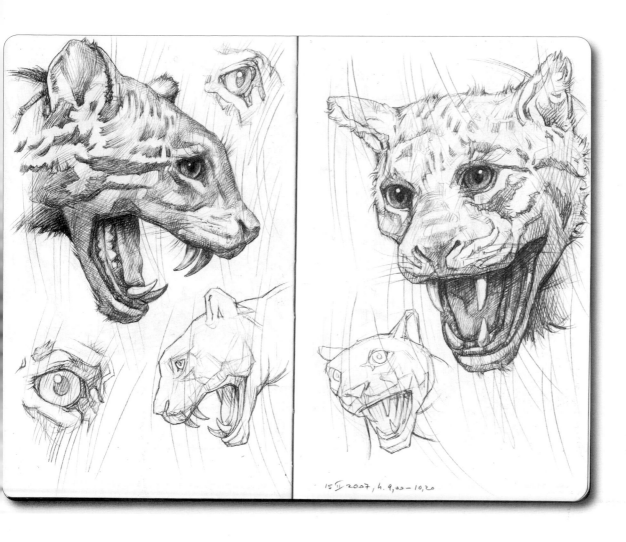

15 II 2007, h. 9,00 - 10,20

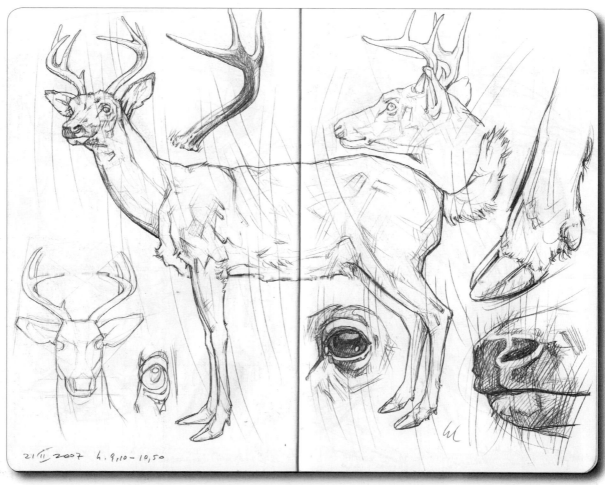

21 II 2007, h. 9,10 - 10,50

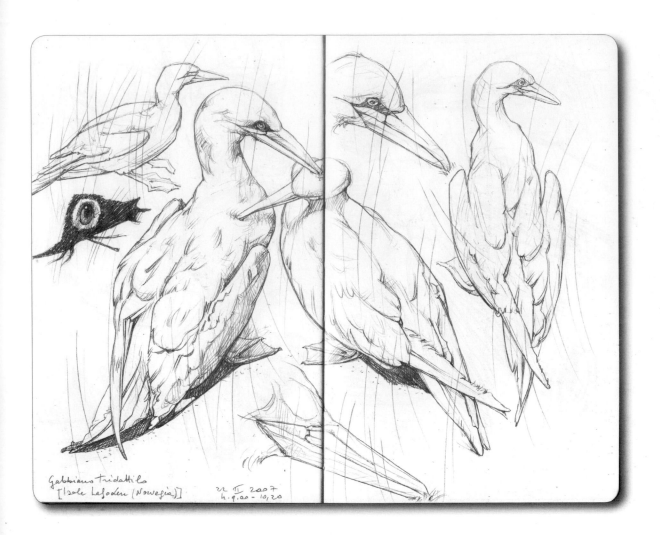

Gabbiano tridattilo
[Isole Lofoten (Norvegia)] 22 II 2007
 h. 9.00 - 10,20

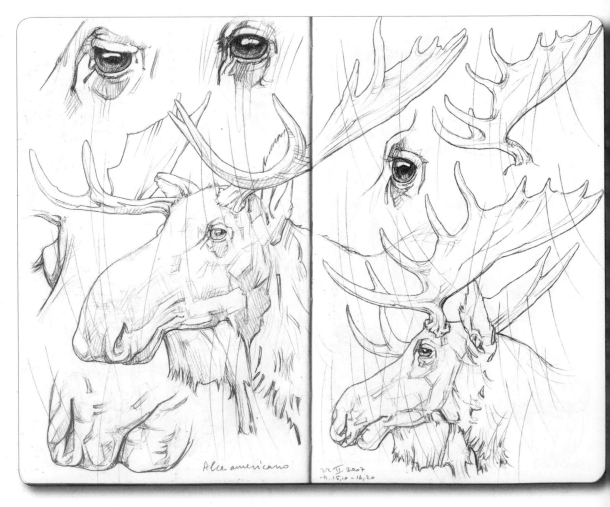

Alce americano 22 II 2007
 h. 15,10 - 16,20

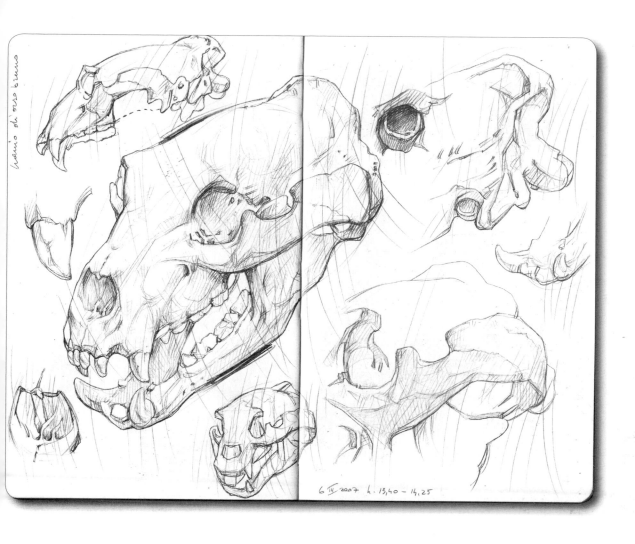

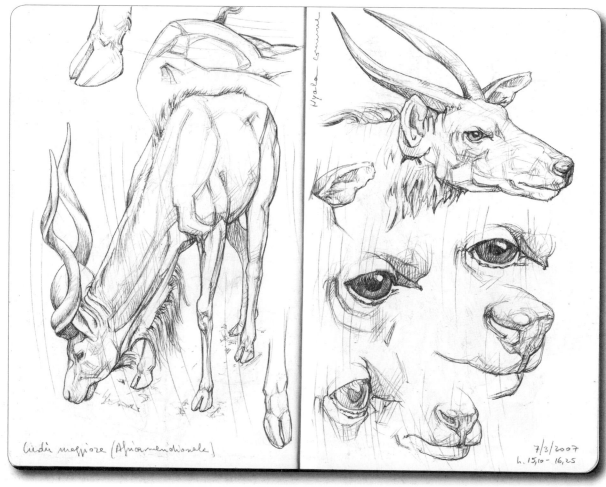

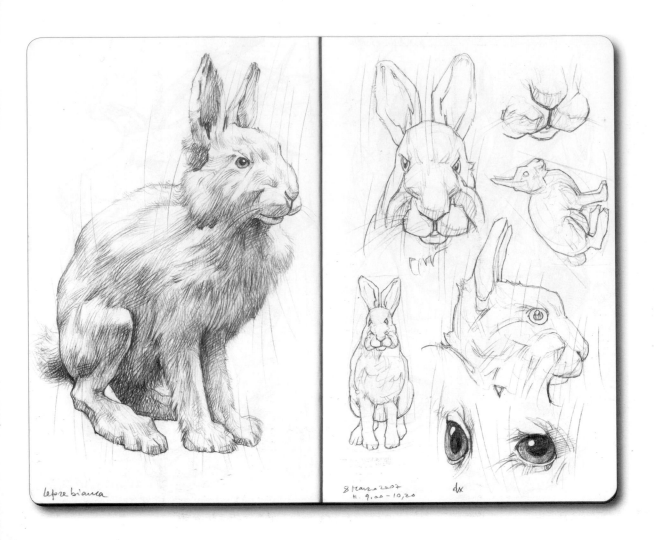

leper bianca

8 marzo 2007
h. 9,00 - 10,20 dx

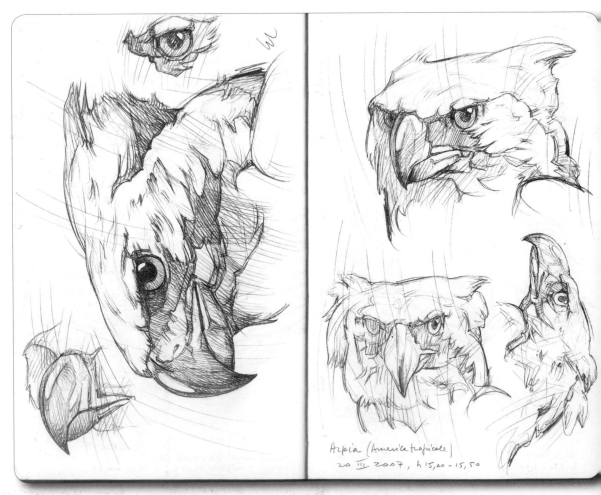

Arpia (America tropicale)
20 III 2007, h 15,00 - 15,50

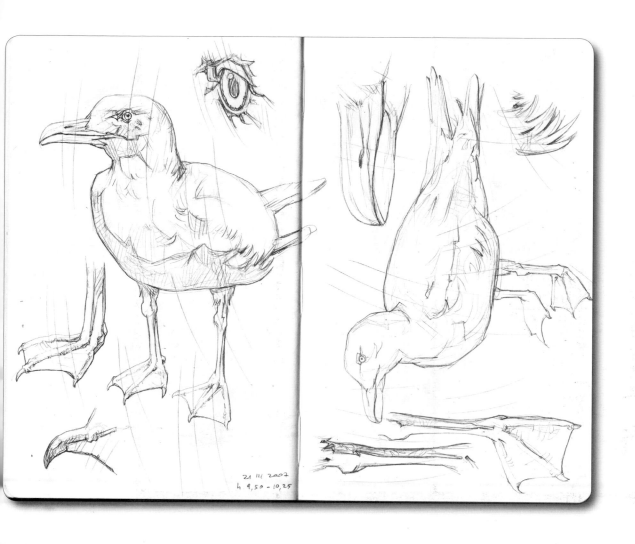

21 III 2007
h 9,50 - 10,25

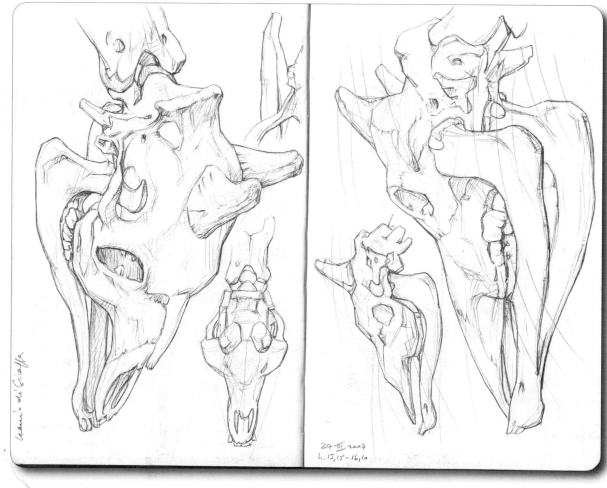

24 III 2007
h. 15,15 - 16,10

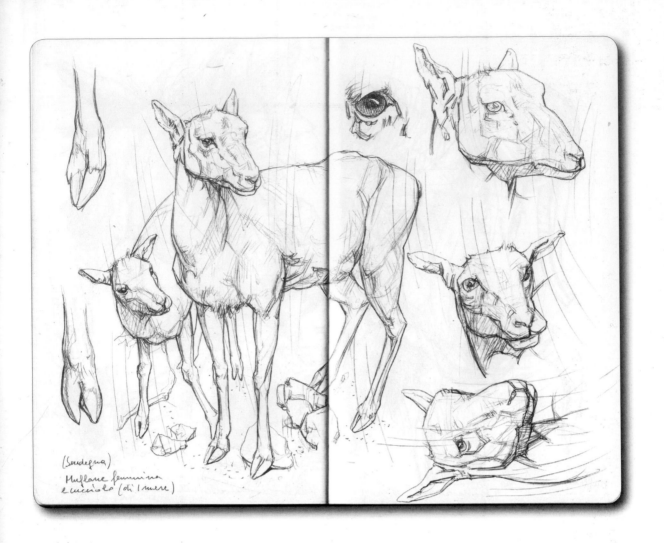

(Sardegna)
Muflone femmina
e cucciolo (di 1 mese)

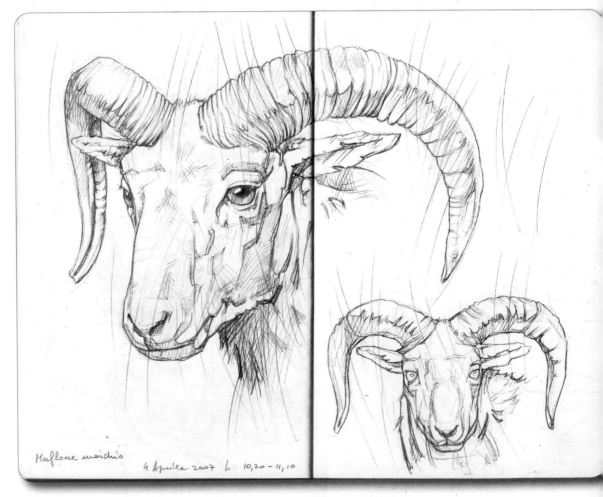

Muflone maschio 4 Aprile 2007 h 10,20 - 11,10